group.sex

group.sex

herausgegeben von / edited by
Eva Grubinger

Verlag / Publishers
lukas & sternberg, Berlin - New York

Impressum / Imprint:

Herausgegeben von / Edited by: *Eva Grubinger*

Mit freundlicher Unterstützung von / Kindly supported by:
Berliner Senatsverwaltung für Wissenschaft, Forschung und Kultur,
Österreichisches Bundeskanzleramt / Kunstsektion, Land Salzburg,
Stadt Salzburg, Galerie 5020, Salzburg, Künstlerhaus Stuttgart

Verlag / Publishers: *lukas & sternberg, Berlin - New York*

ISBN 3-00-002538-3

Organisation / Organized by: *Eva Grubinger, Karin Pernegger*

Redaktion / Editorship: *Eva Grubinger, Jörg Heiser*

Übersetzung / Translation: *Jörg Heiser, Michael Robinson*

Bildteil / Images: *Eva Grubinger*

Umschlag / Cover: *Eva Grubinger*

Gestaltung / Graphic design: *Eva Grubinger, Stefan Rose*

Schrift / Font: *Garamond Berthold*

Papier / Paper: *Claudia 150 g, 250 g/m2, Alster Werkdruck 90 g/m2*

Druck / Printing: *Oktoberdruck, Berlin*

Vielen Dank an / Thanks to:
Clara Drechsler, Renate Goldmann, Britta Pfannkuch, Sven von Reden

Inhalt / Contents

Klaus Theweleit

Bemerkungen zum RAF-Gespenst
'Abstrakter Radikalismus' und Kunst[1]

Background 1: die Irrealität der Sprachsituation im deutschen Nachkrieg. Die Wahr-
nehmung des *Unwirklichen* im Verhältnis der eigenen Existenz zur Existenz der Erwach-
senen (=Verschweiger, Lügner, ordnungshütende Killer), äußerte sich bei der Intelligenz
der jungen Generation in einer Überführung allen Sprechens ins Komische, in Jokes
und Schnickschnacks oder/und im Erwerb des Englischen als Ausweich- und Pop-
sprache, kurz: Elvis Presley und die Absurden (Eugene Ionesco, Samuel Beckett) als die
Erben eines Verstummens der eigenen Rede gegenüber den Ex- oder Immer-noch-Nazi-
Erwachsenen.

Anfang der Sechziger schien die Eruption, die mit dem Rock gekommen war,
wieder unter Kontrolle, entschärft, eingesargt: ein Verpuppungsstadium zur Entfaltung
des fehlenden Anteils *eigenen* Lebens: als Bloß-Fan (von Elvis Presley, Samuel Beckett,
Gottfried Benn, Billie Holiday) kann man z.B. kein Liebesverhältnis entwickeln. Wo ist
der eigene Körper?

Background 2: die Gruppenexplosion von 1967. Es mußte eine Sprache des Öffent-
lichen hinzukommen, die all die zwischen 1956 und 1966 entwickelten Sub- und Grup-
pensprachen aus dem Untergrund hob, sie verband, sie sprechbar machte. Der Schub
kam, politisch, 1967 durch die Sprachen des Marxismus, die öffentlich werdende
Sprache der Psychoanalyse, die Sprache eines sich entfaltenden militanten Internationa-
lismus (Anti-USA/Vietnam), die sich verbanden mit den Sprechweisen des Kinos und
der Rockkultur: insgesamt eine neue Sprechweise einer sexualisierten Frechheit, die alles
ergriff. Großer Mitauslöser: die Pille. Aktionistische, happeningshafte, wissenschaftli-
che, pädagogische, besserwisserische, gewalttätige, berauschte, klatschhafte, intrigante,
verzehrende, selbstdarstellerische, paranoische, narzißtische, lässige, verwirrte, rührende,
fordernde, auch verzweifelte Sprachen und Sprechweisen, befeuert von Liebestönen,
brachen hervor und schufen zum ersten Mal die Möglichkeit einer Verbindung eigenen
Sprechens mit einem öffentlichen Raum: eine neue Art Wirklichkeit, die man

vorher nur behauptet, geahnt, gewünscht hatte.

Background 3: daß der Marxismus ihre Hauptsprache wurde, genauer: das was Reimut Reiche ein 'jüdisch-intellektuelles Rotwelsch', „ein von jungen Deutschen, die sich unbewußt mit der verfolgten und ausgerotteten jüdischen Intelligenz identifizierten, in die gesprochene Sprache transformiertes Amalgam von theoriesprachlichen Begriffen, die allesamt 'jüdischen' Wissenschaften entnommen waren: dem Marxismus, der Psychoanalyse und der Kritischen Theorie", lag in ihrer gemeinsamen Verpöntheit: Sprache aus Marx, Sprache aus *sexuellem* Freud/Reich, Sprache verfolgter Juden konnten die Verbindung mit Sprache aus Elvis Presley und Sprache aus Be-Bop, Sprache aus John Coltrane eingehen, weil sie aus gleichermaßen exterritorialen Bezirken kamen, öffentlich geächtete Sprachen und Klänge waren, ausländische Sprachen, Sprachen von Feinden, 'undeutsche' Sprachen.

Das ist für mich der Kern von '68, die Grundlage dessen, was später bei Deleuze & Guattari *Mille Plateaux* heißen konnte, 1000 Ebenen, 1000 Pole, das Aufbrechen der Stimmen aus den vielen Orten des aufgezwungenen Schweigens, des Hinunterschluckens und des juvenil-senilen Gekichers, des 'Pflichterfüllens' und Mitansehns (traurigen Auges), wie das Land, wie 'das Leben' im elterlich-schulisch-behördlich-polizistisch-arbeitsweltlich vorgeschriebenen Tempo im Geschichtsgully versickerte.

Aus diesem gleichen generationellen Hintergrund kommt auch die RAF, wie vorher schon die Zentralgruppe, die Ende der 60er die politische Situation bestimmte, der SDS, Sozialistischer Deutscher Studentenbund. In Freiburg, wo ich 1967 - nach der Erschießung von Benno Ohnesorg durch Berliner Polizei, die für viele ein Eintrittsdatum war - in den SDS gegangen bin, waren das knapp 30 Leute, in anderen Städten, außer Berlin und Frankfurt, nicht mehr. Die Delegierten-Konferenzen umfaßten vielleicht 60 offizielle Delegierte aus Kiel, Hamburg, Hannover, Berlin, Göttingen, Frankfurt, Marburg, Köln, Heidelberg, Tübingen, München, Freiburg, das die Hauptorte: 1967 zusammen vielleicht 500 Leute. Sich vergrößern, agitieren, war die Hauptarbeit, Leute überzeugen, mehr werden, und zwar durch *Offenheit*. Die Fähigkeit, jede auch noch so wahnsinnige Diskussion stundenlang durchzuhalten, kam aus dem Gefühl unabweisbarer Aufbrüche: des sexuellen wie des politischen Aufbruchs, Freiheit aus der Pille, aus der Sicherheit des Satzes *Make Love Not War*, und aus der 'richtigen Haltung' zu Vietnam – Pro-Vietcong.

Tendenz dabei: je schärfer sich die Sache 'politisierte', desto mehr litt die Sprachenvielfalt; aber es gab z.B. noch keine Verbindlichkeit von Gruppenbeschlüssen, Teile oder eine Minderheit konnten sich abweichend verhalten. Es gab in diesen Jahren auch keine Aufnahmekriterien für die Gruppen, Prüfungen für neue Mitglieder; das alles wurde abgeschafft.

Aber es gab Ausschlüsse auf Delegiertenkonferenzen; die Münchner Gruppe, dominiert von späteren DKP-Leuten, wurde ausgeschlossen, und in Berlin die Kommune 1; dieser Ausschluß wurde von den meisten aber ignoriert. Fritz Teufel, Dieter Kunzelmann gehörten weiter zu 'den Radikalen'. Die Strenge lag woanders, in der Arbeit. Wer im SDS war, mußte im Prinzip den ganzen Tag dafür arbeiten und wollte das auch, die Nächte dazu. Der Gruppenzuwachs war entsprechend gering, es kamen immer mal ein, zwei, drei dazu, bis zum Frühjahr '68, den ersten größeren Aktionen.

Ulrike Meinhof war nicht Teil dieser Entwicklung. Sie kam eher aus Ostermarsch-Bewegung, DDR-Pazifismus und Atomgegnerschaft, also aus der offiziell existierenden Ost-Linken und damit einer offiziell exstierenden Links-Sprache. Sie hatte Schreiben gelernt, talentiert, ohne die oben geschilderten Sprechprobleme, Spracherwerb eher 'homogen'. Und nicht mit diesem Hintergrund Universität, Sexualisierung, Pop und Jazz, sondern relativ frühe Ehe, zwei Kinder und: Journalismus. Der große Moment ihres Journalismus kommt in der Kampagne gegen die Notstandsgesetze, das ist im Frühjahr '68. Sie mündet darin, daß in Bonn sich 80.000 bis 100.000 Leute einfinden und gegen die Verabschiedung dieser Gesetze protestieren. Der Begriff der APO entsteht dabei, zum großen Teil eine Geburt ihrer Zeitschrift *Konkret,* - was dann schnell *Außerparlamentarische Opposition* in allen Zeitungen heißt - Zeitungen vor allem.

Die, die aus dem SDS heraus arbeiteten, standen dem Begriff APO, und dem, wofür er stand, nicht feindlich, aber mit einer gewissen Abwehr gegenüber. Wir empfanden das als eine unangemessene oder auch unfundierte Konkurrenz. Das ist ein Punkt, der von heute nicht leicht zu sehen ist, den ich aber für sehr wichtig halte: das war eine Journalistin. Es gab politisch arbeitende Leute, die den ganzen Tag durch die Gegend rotierten und was vollkommen anderes machten, die wollten nicht in erster Linie 100.000 Typen nach Bonn bringen, die man sowieso nicht organisieren konnte. Wir wollten fünfzehn Leute Zuwachs für unsere Gruppe, das wäre fantastisch gewesen.

Gegen diesen Gesetzeskörper zu agitieren, war zwar richtig, aber nicht unter dem illusionären Aspekt, man könne ihn *verhindern*; das konnte man nicht, trotz der 100.000 Leute in Bonn. Dort hörte man zwar Heinrich Böll reden und sah Erich Fried mühsam mithinken in der Menge und man freute sich, diese Gesichter zu sehen, aber für die Lage an der Uni oder auch für die Lehrlingsgruppen, die sich zu bilden begonnen hatten, hatte dieser Massenauflauf etwas Schädliches, Überflüssiges.

Der 'ersehnte' Effekt trat zu gut ein: die Gruppen vergrößerten sich rapide, im Laufe von 1967 bis 1969 saßen da nicht mehr 30, sondern 120 Leute, die waren in einen Diskussionsprozeß vernünftig nicht zu integrieren. Die Aufteilung in Basisgruppen, in denen der größte Teil der theoretischen und praktischen Arbeit weitergemacht wurde, half für eine Weile. Aber es gab mit einem Mal das, was die Zeitung als „APO-Gespenst" geboren hatte, tatsächlich: eine Menge anpolitisierter Leute, die zu Demonstrationen kamen und zu linken Anlässen und Veranstaltungen. Da standen dann 1000 oder 2000 auf der Straße und protestierten gegen Vietnam und für Kuba, aber die politische Arbeit oder Agitation - wie macht man aus Leuten eine Sorte von Sozialisten, die nicht dem DDR-Sozialismus anhängen, sondern dem Prinzip 'Lust & Freiheit' - litt darunter. Ob das nun Sozialismus heißen mußte.... gut, man probierte Marx aufzufassen, auswendig zu lernen, anzuwenden, zu diskutieren. Aber das hatte seine Begrenzung an der Stelle, wo 'das Leben' anfing, wo Liebesverhältnisse anfingen, wo man Musik machte, las[2] und wo man trank. Alles war hoch alkoholisiert, Nächte ohne Alkohol unmöglich, schlafen ging fast niemand vor der Morgendämmerung. In der Mensa mittags Flugblätter verteilen, Büchertische, Treffen mit Genossen, im Cafè hocken, reden, Aktionen entwickeln, Kino, in Seminare gehen, dort diskutieren, Leute politisieren, nächstes Flugblatt entwerfen, dazwischen die Beziehungsdiskussionen, zu zweit und mit mehreren, dieser Rhythmus in einer aufgedrehten Mischung von bohemistischen und politischen Elementen. So was wie ein Dogmatismus, Entwicklung einer 'Linie', der man folgen mußte, konnte sich dabei nicht entwickeln und sollte sich auch nicht entwickeln.

Nichts davon war im Kern journalistisch, nicht mal die Flugblätter; sie gingen immer auf 'direkte Aktion'. Es gab viele Genossen, die nicht einmal Zeitung lasen, es sah auch fast niemand fern: die Zeit war nicht da, und auf die Quarkköpfe im Fernsehen konnte man verzichten, Nachrichten sowieso. Man sah Filme.

Für die Zerstörung der SDS-Kerngruppen auf 1970 zu habe ich immer als mitent-
scheidend empfunden, daß die Gruppen sich, im APO-Fahrwasser, zunehmend an
Kampagnen hängen ließen. Rein reaktiv etwas bekämpfen, was woanders beschlossen ist,
bekämpfen, was man nicht aufhalten kann: da läuft man hinterher, richtet seine Organi-
sation danach aus, organisiert die Busse, karrt die Leute zu idiotischen Plätzen, kloppt
sich ein bißchen mit der Polizei, fährt nach Hause (liest sich in der Zeitung), und hat
wieder was nicht verhindern können, dies oder jenes Gesetz. Journalistenpolitik: Kampa-
gnen anleiern ist die einzige Möglichkeit für Journalisten, sich direkt in politische Basis-
vorgänge einzuschalten, 'abstraktes Mobilisieren'. Ich fand das behämmert, aber dieser
Mechanismus war nicht abzustellen (später kamen so witzlose Sachen wie der Volks-
zählungs-Boykott da raus).

Betriebsarbeit war der nächste Komplex, als die Gruppen größer wurden. Aus den
vielen SDS-Gruppen heraus gab es schon eine Weile IG Metall-Wochenenden und ähn-
liches. Lehrlinge in Marx zu unterrichten, so gut man das konnte, war das eine; wichti-
ger aber, die Person, die das machte. Warum wollten auch Gewerkschafter, daß man da
auftauchte, warum wollte der IG Metall-Vorsitzende des Kreises SDSler bei sich haben
und karrte seine Lehrlinge an? Weil 'etwas im Raum war', eine ungeheure Attraktion,
aufgeschlossenere Leute aus Betrieben wollten diese Uni-Intellektuellen sehen und
hören; man war zwar nicht Arbeiter - nur wenige hatten Betriebserfahrungen - aber die
Arbeiterbewegung, die gestorben gewesen war, vernichtet im Faschismus, dann in der
Bundesrepublik verdrängt und abgeschoben nach 'drüben', erstand merkwürdigerweise
durch diese Studenten ein bißchen wieder auf.

Diese Arbeit spaltete den SDS aber in verschiedene Lager. Es war ein ungeheurer
Lernhunger da auf allen Seiten und Linien, aber je größer die Gruppen wurden und sich
das Arbeitsfeld erweiterte auf verschiedene gesellschaftliche Bereiche, desto notwendiger
wurde es für viele, einer definierten Linie zu folgen, aus Gründen der eigenen Verhaltens-
sicherheit. Diese Art Leben ist sehr auszehrend. Wenn man das zwei bis drei Jahre
macht, Aktions-Leben in permanenter Selbstüberforderung - und auf diesen Zeitraum
bewegte sich das zu - gelangt man an die Grenze psychischer wie physischer Zusammen-
brüche. Das Studium war für viele sowieso aufgegeben, Lehrer konnte man nicht mehr
werden, die meisten Linken hatten längst 'ihre Akte', man wußte, beim Verfassungs-
schutz liegt stapelweise dieses Zeug, man wird nicht Lehrer oder Professor, Staatsbeamter,

werden können, also braucht man auch nicht zu Ende zu studieren - obwohl es die Berufsverbote offiziell noch nicht gab, aber sie kamen, genau wie vorhergesehen.

Viele wählten den Schritt aus der Uni hinaus, um Betriebsarbeit zu machen; sie wollten sich nicht mehr universitären Gruppen fügen. Der berühmte 'Hauptwiderspruch' wurde zur Leitfigur erhoben, der alles verschlingende Widerspruch zwischen Arbeit und Kapital. Wer das nicht mitmachte - das ging mit einem Mal sehr schnell - wurde als Nicht-Marxist angesehen und behandelt; eine sich marxistisch nennende Dogmatik setzte sich durch in diesem Moment Anfang der Siebziger.

Der SDS löste sich Ende '69 auf, wie ein platzender Luftballon. Einige blieben in der Hochschule, andere machten 'Betrieb', sie gründeten Parteien mit dem 'K' vorne, die sogenannten 'K-Gruppen'. Andere wurden mehr oder weniger 'privat', arbeiteten für sich weiter oder versuchten sonstwie, eine Art von Berufsentwicklung hinzukriegen. Ich bin in dem Moment für ein paar Jahre als sogenannter freier Mitarbeiter ins Radio gegangen, über einen Freund, weil ich mit dem zwanghaften 'K-Kommunismus' nicht kompatibel war.

Entscheidend für die Tiefe des Bruchs war dabei persönliches Verhalten: die Leute, die sich abtrennten und 'K-Gruppler' wurden, kannten einen nicht mehr, von einem Tag auf den anderen. 'Genossen', für die man am Tag vorher unter allen Umständen alles riskiert hätte, z.B. wenn jemand verhaftet wurde und war allein: dann griff man Polizisten an, stieß sie um, warf sie in die nächste Hecke, das ging in den ersten ein, zwei Jahren der relativen 'Polizeiunsicherheit'. Die selben Leute, mit denen man so verbunden gelebt hatte, noch eine Nacht, noch eine Woche vorher, waren mit einem Mal 'Feinde', - wenn sie was 'gegründet' hatten. Diese 'Gründungen': „Wir heißen jetzt KPD sowieso, Lenins Roter Morgen, ML [Marxistisch Leninistisch], AO [Aufbauorganisation], ich bin Leiter der Betriebsgruppe dütdütdüt"; wenn man fragte: „Was ist denn das für 'ne Betriebsgruppe, bis gestern gab's die noch nicht": „Doch - das ist geheim, dazu sag ich dir nichts." Und die Leute fingen an, die Straßenseite zu wechseln, wenn man ihnen begegnete.

Das klingt grotesk, aber es war ein solcher Zusammenbruch. Bei den einen ein psychischer Zusammenbruch aus dem Nichtmehraushalten des jahrelangen Rotierens in der politischen Arbeit, des Immer-auf-der-Höhe-Seins im Theoretischen, und des gleichzeitigen Anspruchs, sowohl vernünftige Liebesverhältnisse zu entwickeln, aber

auch freie Sexualität - das Recht, mit jeder Frau zu schlafen, das Recht, mit jedem Mann zu schlafen, aber trotzdem *ein wirkliches* Liebesverhältnis zu haben - das machten viele über längere Zeit nicht mit, Frauen brachen an dem sexuellen Punkt meistens schneller zusammen als Männer, Männer brachen an anderen Stellen zusammen, sei es an Alkoholismen, einige soffen sich zu Tode, andere brachten sich um, Frauen auch.

Bei den K-lern, war es eher ein Zusammenbruch durch 'Reduktion': die Welt schrumpfte zusammen auf ein paar Hauptzüge, die keiner *Wahrnehmung* mehr bedurften; alles wurde 'Setzung und Satzung', kaschiert mit Hyperaktivität, Gehorchen statt Denken, ein Total-Zusammenbruch.

Die freiere Politik ging woanders weiter: Anti-AKW, Frauengruppen, Filmgruppen, Musikgruppen im Sponti-Umfeld; viele der sogenannten Spontis dabei aber eher verhinderte Partei-Kommunisten...

In dieser Situation - und ich glaube, man kann die RAF und deren Politik überhaupt nicht kapieren, wenn man diesen Hintergrund nicht vor Augen hat - in dieser Situation genau, kommt Ulrike Meinhof aus *Konkret* heraus. Abstrakt radikalisiert, und findet vor: Nichts. Nicht die Massenbewegung, die sie sich unter dem Namen APO zusammengeklappert hat auf ihrer Maschine. Radikal rotierend im Nichts, treffend auf Geheimgesellschaften, Splittergruppen, einzelne Privatlinke oder dogmatische Parteikommunisten, und verbindet sich mit der relativ militantesten oder anarchistischsten Gruppe, die übrig ist, den Kaufhausbrandstiftern um Andreas Baader und Gudrun Ensslin.

Sie bilden die RAF (Rote Armee Fraktion), zur Vorbereitung des 'bewaffneten Kampfes', eine Speerspitze im Leeren. Was hätte sie sonst tun können? Die politische Grundlage, die sich angeboten hätte, wäre Arbeit in der Frauenbewegung gewesen, denke ich. Aber da war Alice Schwarzer, und von da kam Ulrike Meinhof ja gerade, vom Journalismus. Mühsam die Trennung und Scheidung hingekriegt von Klaus Rainer Röhl, der ein Ekel gewesen sein soll, ich weiß das nicht und sage dazu nichts, auch nicht dazu, wie und warum sie die Kinder zurückgelassen hat. Jedenfalls hat sie sich mit großer Mühe befreit aus diesen Zusammenhängen, um genau das *nicht* zu finden, was sie von 'der Lage' erhofft hatte. Ich denke, schon die Gründung der RAF ist ein Verzweiflungsakt in der Leere, der politischen Leere in puncto 'Radikalismus', die enstanden war Anfang der Siebziger.

Ulrike Meinhof wird somit Teil einer großen Reduktionsbewegung: Das, was ich vorhin als Sprachexplosion beschrieben habe, ist genau wieder zurückgenommen worden Anfang der Siebziger. Eingeschnurrt, eingeschmolzen auf zwei, drei vorgeschriebene, beinah institutionalisierte Sprachen, diese Einschätzungssprachen aus Links-Instituten. Von China bis Angola jede Woche in sein Parteiblatt reinzukriegen, wie die Weltlage ist, in immergleichen Sätzen, mit ein paar Mao-Zitaten garniert. Oder, bei der RAF, wie der politische Kampf, der anti-kapitalistische, bewaffnete Kampf läuft in den verschiedenen Weltgegenden, mit genau der gleichen Sorte eingeschränkter Sätze, von Südamerika bis Vietnam: zum Wahnsinnigwerden.

Nicht nur die Sprachen wurden dichtgemacht, auch die Straße wurde geschlossen. Genau das, was erobert worden war - Straße, Öffentlichkeit, Offenheit und Sprachvielfalt nach allen Seiten - verschwand in ein, zwei, drei Jahren im Geschichtsgully. Nicht ganz, als hätte es das nicht gegeben, bei einigen hier und da ging es weiter, aber eher privat oder nostalgisch infantilisiert. Bei den öffentlich relevant bleibenden Gruppen, gerade bei den 'K-Gruppen' und der RAF, die als übriggebliebene 'radikale' Gruppen ins Zentrum der politischen Bewegung rückten, aber Sprachverengung, Denkverengung. Daraus resultiert, was ich heute 'abstrakten Radikalismus' nenne, ein Radikalismus, der sich auf Gesten, auf Ansprüche, auf Forderungen beschränkt, revolutionäre Haltungen verbreitet in Sätzen, Parolen, dabei Analysen kaum mehr durchführt. Diese ganze mühsame Arbeit, das Gewimmel und Durcheinander des Wirklichen in Sätze reinzukriegen, die halbwegs stimmen, die in irgendeiner Weise mit dem, was man sieht, was man wahrnehmen kann, übereinstimmen, wurde aufgegeben. Es spielte keine Rolle mehr. Zu 'stimmen' hatte etwas nur noch in einem rücksichtslos abstrakten Sinn. Das 'Konkrete' wanderte aus aus der linksradikalen Politik (und fand Asyl, für eine Weile, in der Frauenbewegung).

Wohin mit dem eigenen Anspruch? Die meisten Leute, die im SDS gearbeitet haben, wollten nicht aufhören, wollten weitermachen in dem, was noch da war, 'K-Gruppen', RAF. In jeder Wohngemeinschaft, jedem Zirkel, brach die zerfleischende Diskussion aus, RAF oder nicht RAF, oder wenigstens 'K'? In fast jeder SDS-Gruppe gab es einen radikalisierten Südamerikaner, der südamerikanischen Guerilla-Formen nahestand, warum dasselbe nicht hier? In Freiburg war es ein Argentinier, in der Funktion etwa von Gaston Salvatore in Berlin bei Rudi Dutschke. Solche Paare, Drittwelt-Erstwelt,

oder umgekehrt, ziemlich symbiotisch verbunden und oft Motoren ihrer Gruppe, fingen an, sich über diesen Punkt in die Haare zu kriegen, zu entzweien. Dutschke hatte, für mich deutlich und richtig, gegen Attentatspolitik gesprochen: es nütze nichts, irgendeines dieser politischen Großgesichter abzuknallen, ein anderes kommt an seine Stelle, die Herrschaft ist personell nicht faßbar; ob der Arbeitgeberpräsident der oder der oder jener ist, ob in Persien dieser Schah oder ein anderer regiert, ist belanglos. Die Herrschaft wird von gesellschaftlichen Gruppierungen, Industrien, ökonomischen Schichten ausgeübt, die nicht zu verwunden sind durch einzelne Terrorakte, weder in der bürgerlichen Gesellschaft noch in halbfeudalistischen Drittwelt-Staaten. Diese Diskussion war eigentlich gelaufen, als die RAF ihre Terrorakte begann. Was wir 'revolutionäre Gewalt' nannten, sei es in Vietnam, sei es in Südamerika, in Cuba, stand dabei nicht zur Debatte, sie wurde vorbehaltlos unterstützt. Es ging nicht um 'keine Gewalt', sondern: keine Einzel-Attentate. Den SDS, die Sicherheit dieser politischen Argumentation, gab es aber nicht mehr, 1972 und danach. Man mußte dies im Kleinkrieg-Hickhack 'des Privaten' klären.

Die RAF als vielfaches Gespenst gibt es schon da: für die einen mußte sie herhalten als Beweisstück für den 'faschistischen Charakter' des BRD-Staats; - eine Gewißheit, die nach der Amnestie für 'Straftaten' aus dem Umkreis der Studentenbewegung nicht ganz leicht am Leben zu halten war. Für andere war sie *der Beweis* der Möglichkeit effektiver Gegenwehr: es *geht* mit der Waffe...

Die Schärfe und panikhafte Hetze, mit der die SPD unter Helmut Schmidt und die anderen Bonner Parteien auf die RAF reagierten: Als sei das *die Rote Armee* selber, schon 'vor den Toren Bonns', gab dem Gespenst die fehlende Schubkraft zur Ausbildung seiner Riesenhaftigkeit.

Daß die BRD sich im Falle einer realen 'Linksbedrohung' wie eine Fortsetzung des faschistischen Staates verhalten würde, war eine geteilte Ansicht der meisten 68er. Die Nazi-Richter waren nicht ausgewechselt worden, der Justizapparat nie entkämmt, die Nazi-Verwaltungen nicht, die Mordindustrien waren ungeschoren geblieben, die Banken, die Historiker wie die Presse hatten sich geeinigt auf den großen Schweigepakt zum Holocaust; zum Krieg bekam man Lügengeschichten, der unbeirrt sauberste aller Panzerfahrer saß im Kanzleramt. Was war da zu erwarten?

Trotzdem lag bei den meisten, neben der gewalttätigen Wut auf den Zustand des Landes, ein klarer Pazifismus in der Waagschale. Unsere Generation war die erste bewußte nicht-soldatische in Deutschland seit Urzeiten; es war mit ihr auch nicht möglich, sie ins Kriegsgully abzutreiben, wie das immer gemacht worden ist und immer wieder gemacht wird mit „störender Jugend" in autoritären Gesellschaften.[3]

Also *nicht* in die RAF. Abstrakt gab es die 'Verpflichtung', ein Gewehr zu nehmen und (zumindest) in den internationalen Befreiungskämpfen mitzutun, Vietnam, Mao ...„Die Macht kommt aus den Gewehrläufen": jeder sagte diesen Satz, andauernd. 'Abstrakt' hätte ich somit eher zur RAF tendiert als zu den 'K-Gruppen'. Ich bin zu einer 'K-Gruppe' anfangs gegangen, meine damalige Freundin und jetzige Frau nicht. Gruppen mit Befehlen, Hierarchien - das geht nicht! Wozu hat man revoltiert, jahrelang, wenn man sich jetzt einer Gruppe anschließt, die einem vorschreibt, nach Stuttgart zu gehen in einen Betrieb, wo sie dich hinschicken, weil da etwas 'aufzubauen' ist, und auch noch streng 'geheim'. Das kam nicht in Frage: ein absolutes Dementi dessen, was vorher politisch probiert worden war: „Bist du denn verrückt?"

Ebenso verrückt die RAF-Seite: „die Guerilla als Fisch-im-Wasser unserer Städte" - das konnte mir keiner weißmachen: da war kein Fischwasser um einen rum, in keiner Stadt in Deutschland, keinem *Stadtteil*. Im Höchstfall ein paar Leute, die einen (kurzfristig) versteckt hätten. Dafür Millionen Bildzeitungsspitzel.[4] Der Schwarzwald als Guerilla-Basis! Man braucht da nur mal einen Tag mit dem Auto hinfahren und ein paar Schritte im Gelände machen als nicht ausgewiesener Wildtöter (oder Wander-Sepp), dann hat der Förster einen registriert und gemeldet. Jeder Spaziergänger zeigt einen an, auf jeder Wiese, an jedem Hügel, wo man steht, in den Städten ja nicht anders, wenn man sich in irgendeiner Weise 'verdächtig' zeigt(e).

Daraus die nächste Wahrnehmung: es stimmt nicht, was die Leute erzählen, was sie schreiben, wie sie agitieren, was sie sich versprechen, wie sie die deutsche Gesellschaft revolutionieren wollen, nichts stimmt, es stimmt kein Wort. Dabei lag - das hatte ich die Jahre vorher gelernt - die Existenzberechtigung für das eigene Agitieren darin, daß es *stimmen* mußte, was man schrieb. Daß es in irgendeiner Weise mit der Realität zusammenhängen mußte, nicht ersetzbar war durch Sätze wie: „Kill the pigs", tötet die Schweine. Oder, bei den 'K-lern': „Wir brauchen diese Differenzierungen nicht." In Frei-

burg verkauften sie als erstes den gesamten Bestand des linken Buchladens, der mühsam aufgebaut worden war die drei, vier Jahre vorher. Alles wurde verscheuert, es blieb nur Mao übrig und drei, vier andere Texte. Sie kauften Druckmaschinen von dem Geld und druckten ihre KVZ und andere Blätter, in denen immer dasselbe stand, die selben Sätze zur täglich neuen Weltlage.

Für mich waren das keine 'Linken' mehr. Diese Gruppen bekamen was organisatorisch Rechtes, sowohl die 'K-Gruppen' wie die RAF, im Innern bei beiden: Kommandostrukturen. Nix Gleichheit, nix Analysen. Die einen sahen ab von allen Realitäten, die andern setzten reale Gewalt an die Stelle von Formeln wie „weg mit!", wobei für mich gleichzeitig immer festgestanden hatte, daß Gewalt, bedingt durch die nazistischen Morde, *das deutsche Problem* überhaupt sei: daß man als jemand, der freiere Lebensformen oder Lebensweisen wünscht, Gewalt hier bekämpfen muß. Gewalt in Deutschland ist legiert mit Gestapo-Gewalt, KZ-Gewalt, der elterlichen Terrorgewalt, der des Prügelns wie der des Verschweigens. „Bewaffneter Umsturz in dieser Gesellschaft?" „Wen willst du denn töten?" Ich, von mir aus, niemand.

Die 'K-Gruppen' reduzierten sich im Laufe der Jahre selber auf Null durch gegenseitige Ausschlüsse, bis keiner mehr übrig war, also nach Stalinismus-Gewaltprinzip. Bei der RAF ein ähnlicher Prozeß: Beschimpfungen derer, die nicht mitmachten und Todeswünsche gegen Abweichler. Die Briefe, die ich jetzt in den letzten Wochen gelesen habe[5] zeigen, daß sie dies Prinzip ausdehnten auch auf sich selber, eine verbale Dauer-Tötung untereinander.

Man könnte sich fragen, wann die Ansicht, daß RAF und 'K-Gruppen' etwas Rechtes haben, sich bei mir entwickelt hat - damals schon oder erst retrospektiv. In der Tendenz nicht retrospektiv, in der Ausformulierung schon. Der Entschluß, nicht in der 'K-Gruppe' weiterzumachen - gegen alle möglichen eigenen Widerstände - war da. Und war nicht einfach. Ich kenne viele Leute, für die ging vor allem der Entzug 'der Straße' - man konnte nicht mehr politisch raus ins Offene - bis ins Gehen, die Beine wurden steif. Man kriegte den Fuß nicht vor den anderen, man wußte mit dem ganzen Körper nicht, wohin in dieser Zerreißung. Ich weiß nicht sicher, wie ich mich letztlich entschieden hätte, wäre meine Frau nicht entschieden gewesen. So hätte 'K-Gruppe'/RAF für mich bedeutet, die Beziehung zu ihr abzubrechen. Das wollte ich nicht.

Wir haben uns '72, das war eine regelrechte Überlegung, entschlossen, Kinder zu kriegen. Wir gehen von diesen Gruppen weg, machen eine Familie. Nach und nach fing man auch an, ein bißchen von den alten kommunistischen Texten zu lernen. Was ich dann später die Selbstvernichtung der Linken in den Dreißiger Jahren genannt habe, also wie es bei Georg K. Glaser, bei Jan Valtin steht, Franz Jung, das wußte man alles nicht. Daß 'die Genossen' einen nicht mehr kennen, einen nicht mehr sehen konnten und wollten - das war ja nicht so neu. Das war *auch* eine kommunistische Tradition. Umso horrender wurde das, was die 'K-Gruppen' machten. Die Neuerfindung eines Sandkasten-Stalinismus in den Siebzigern.

Man kann das überprüfen bei mir daran, daß das *Männerphantasien*-Buch 1977 erschienen ist, es enthält eine Menge davon, ist genau in diesen Jahren geschrieben, parallel zu diesem Anti-Gruppen-Prozeß, zu Hause bleiben, sich ums Kind kümmern, meine Frau fing an zu arbeiten in der Klinik, halb Schreiben und halb Kinderarbeit, wir haben uns das geteilt. Die Zeit mit Kind (und dann andern Kindern, befreundeten), entfernte schließlich am stärksten von den politischen Zwangsgeschichten, ergab einen anderen Blick: ein Vormittag alleine zu Hause mit einem Kind, das auf dem Teppich rumkrabbelt und anfängt, sich eine Welt zusammenzubauen, läßt den Blödsinn dieses 'Rotierens' so sinnfällig werden wie nichts sonst. Ein anderes Gefühl von 'Linkssein', es machte noch klarer, daß 'K-Gruppen' wie RAF sich immer mehr von dem entfernten, was ich und viele andere als 'links' entwickelt hatten die Jahre davor.

Jetzt ging es nicht mehr um Lebensentfaltung, sondern das Gegenteil: Opferungsvor-gänge: ein Punkt, der gerne übersehen wird bei allen politischen Gruppen aus ganz naheliegenden Gründen. Man hat dieses merkwürdige Phänomen: warum ist Rudi Dutschke im Lauf der Siebziger tot, Hans-Jürgen Krahl - das war ein Autounfall - verschwunden, fast aus jeder SDS-Gruppe wird man einige nennen können, aus den ausgestellten Positionen, aus der Mut-Position, dem Sich-Aussetzen, sich vor Säle stellen, reden, selber nicht genau wissend, wie man das macht, kann man das über-haupt, ist man dazu berechtigt, sich durchzusetzen gegen tausend schreiende Leute, die sagen: „Halt' die Klappe", die genervt aufstöhnen beim Wort 'Marx', oder, noch schlimmer, 'Freud'. Freud vor allem ein rotes Tuch: wenn man vor Versammlungen mit Behandlung des Kleinkinderkörpers anfing, gab es einen Aufschrei des Protests

und des Widerwillens, was hat das mit Politik zu tun! - und dann dabei zu bleiben, das auszuhalten, sich durchzusetzen: nach einer Weile kennt einen jeder in so einer Universität, teils auch in der Öffentlichkeit der Stadt. Diese ausgestellten Positionen sind immer höchst gefährdet, für alle Leute, die sie sich zuziehen. Zwar kriegt man einerseits Gratifikationen, darf sich als Leader und Mensch von Einfluß verstehen, auch als jemand, der denkerisch, rednerisch oder sonstwie auf der Höhe ist.

Aber man wird gleichzeitig ein „Giftcontainer" - wie Lloyd deMause, New Yorker Psychohistoriker, das nennt - mit diesem für mich sehr treffenden Begriff: Sowohl die Anhänger wie auch alle andern, die einen in der Öffentlichkeit angucken, schütten ('projizieren') bestimmte Dinge in einen rein, laden Phantasien ab, delegieren Wünsch, Aufträge, Verbote. Man wird zum Träger dieser Dinge, zum 'Container' eben, soll dies tun und jenes lassen, und es wird einem nicht verziehen, wenn man etwas davon nicht ausagiert. Man wird konstruiert im Blick der Andern als eine bestimmte Art Täter, wenn man sich diese öffentlichen Positionen zuzieht oder anmaßt.

Profi-Politikern macht das nichts aus, sie leben davon, leiden nicht darunter, im Gegenteil: sie können das genießen, als Macht- oder Stimmenzuwachs. Leute, die nicht Aufstiege in Führungspositionen im Sinn haben, denen vielmehr daran liegt - ruhig anmaßend gesagt - die Masse zu entwickeln, ein Teil von ihr zu sein, nicht auf Podesten zu hocken, sondern politische Initiativen und Aktionen anzukurbeln, die auf sowas wie Gleichheit zielen, befreites Handeln, geraten unter einen ungeheuren Druck, sie spüren den Widerspruch: als Autoritäten verschwinden zu wollen, aber mit Führergewichten ausgestattet zu werden. Jean Luc Godard hat das mal sehr spitz formuliert in dem Satz: „Wer zu mehr als zwölf Leuten sprechen kann, ist ein Diktator."

Einerseits 'Diktator' also, andererseits 'Container', in den andere Gift & Wünsche hineinfüllen. Das gilt auch für alle Titelblattleute, die auf die Covers kommen. Von Diana bis sonstwo - das sind immer Todespositionen. Denn die Giftansammlungen - z.B. durch Nichtagieren können oder sich hilflos und eingesperrt fühlen, durch Macht-losigkeiten - entladen sich in einem Rhythmus, den Lloyd deMause in vier Phasen unterteilt: erst wird man geliebt wie in einer Ehe, im „Honeymoon", dann kommen die Brüche ins Bild, das nennt er die „Cracking Phase", das nächste ist eine Giftphantasie in der Gruppe, sie zerfällt, sei es durch (phantasierte) feindliche Infiltrationen, Unterwanderungen oder auch wirkliche Überlegenheit des Gegners: „Paranoid Collapse Phase".

Man kann das bei fast allen politischen Gruppen beobachten wie auch auch in der Einzelbeziehung. In der vierten dann, dem „Blackout", kommt es zu einem kämpferischen Zusammenknall, oder auch Implosion in einer Gruppe. Die Führungsperson kann darin überleben, wenn die Gruppe 'einen Sieg erringt'. Amerikanische Präsidenten, an denen deMause diese Vorgänge beschreibt, starten z.B. immer einen kleinen Krieg in diesem Moment, Grenada, Panama, Carters Hubschrauber-Aktion im Iran, da klappte es nicht so, dann wird er abgewählt. Bei anderen klappt es, dann Wiederwahl. Oder es gibt den Königs- oder Führerselbstmord: wenn er es nicht schafft, die Giftmengen, die die Anhänger auf einen abgeladen haben, zu kanalisieren, unter Kontrolle zu bringen, zu entsorgen. Dann muß er abtreten, sich selbst opfern (Nixon/Watergate), so daß ein Neuer an diese Stelle tritt und die Gruppe eine Transformation durchlebt.

Dieser Prozeß, insbesondere „Paranoid Collapse Phase" und „Black Out", ist 1975-77 für mich an der RAF abgelaufen. Es war eine ungeheure Menge schlechten Gewissens (Gift) aufgestaut bei all denen, die nicht der RAF gefolgt waren. Ob aus den besten Gründen oder den schlechtesten, ob nur aus Angst oder Feigheit, ist egal - wichtig war dies Gefühl, nicht genug getan zu haben, das hatten fast alle 'Symphatisanten'. Es äußerte sich darin, diese Gruppe, die so viel und 'für alle' zu tun schien, abstrakt zu unterstützen, aber genau wissend, das endet in einem Tod - das *kann* nur in einem Tod enden.

Heute sehe ich eine Art von Zusammenarbeit: eine Gruppe, die in radikalster Selbstausstellung sich anbietet, geopfert zu werden, Anhänger, die dieses Opfer annehmen oder sogar verlangen (die sogenannten 'Symphatisanten'), drittens ein Staat oder eine Polizeigewalt, die dies Opfer durchführen.[6] Die meisten der sogenannten 'Symphatisanten', Intellektuelle, Künstler, Uni-Professoren hatten mit irgendeiner praktisch-radikalen Politik nichts zu tun. Ihr Selbstvorwurf ungenügender 'politischer Praxis', beladen mit Schuldgefühlen (= Giftstau), löst sich unterm Druck der Gruppe, die sich ausstellt als einzig revolutionäre (und freiwillig die Jesus-, die Kreuzes-Position übernimmt), in eine deutsche Erlösung: 'Herbst-Melancholie'. Diese Form von Zusammenarbeit zwischen einem politischen Outlawtum, das die Übertretungen liefert, einem Staat, der die (rituelle) Opferung durchführt, und einer Gruppe, die (nach großem Aufschrei) übrigbleibt und gereinigt weitermacht, ist modellhafte Giftcontainerpolitik im gesellschaftlichen Vollzug bestimmter Gruppenphantasien (sie kommen übrigens in

allen 'Lagern' derart vor; u.a. darin sind Begriffe wie 'links' oder 'rechts' im Lauf der 80er Jahre in ihre Auflösung eingetreten).

Den Eintritt ins gesellschaftliche Opferritual kann man bei der RAF ablesen an der Abnahme der analytischen Qualitäten ihrer Papiere. Gibt es am Anfang noch Rudimente eines analytischen Zugriffs auf Verhältnisse[7], findet man bald nur noch eine argumentative 'Entleerung'. Bei mir hat die Lektüre immer schneller an dem Punkt geendet, wo Sätze kamen von der Art: „Wer uns nicht unterstützt, unterstützt faktisch die bundesrepublikanische Justiz, Punkt. Da ihr die bundesrepublikanische Justiz unterstützt, seid Ihr Schweine, Punkt, ihr seid eine Fraktion der Pigs..." das fehlte nirgends. Später erscheint die Formel, wer nicht denkt wie wir, hat „unmaterialistische Scheiße im Hirn", auch in den Briefen der Gefangenen untereinander: „der punkt ist, dass die situation täglich anders ist und du einfach unmaterialistische scheiße im hirn hast", so Ulrike Meinhof an Irene Goergens, 11.10. 74.

Vorschreiben, was der andere tun und was er lassen soll, wir sind beim Militär und in der *Familie*, - die Mama bei Franz Jung: „Der Junge spielt doch nicht richtig, hält die Geige nicht richtig, kuckt nicht richtig in die Noten. Komischerweise stimmt, was er spielt, aber er müßte es doch ganz anders machen." Dieser Komplex des 'Mama will es aber *so*', die Dressur der frühen und späteren Kindheit, Schulzeit, kommt aus den Briefen der RAF-Gefangenen aus allen Poren herausgeströmt. Vorschriften, Anweisungen, Richtlinien, Vorwürfe, Appelle, Papa/Mama O-Ton, Befehle. „Du mußt lernen, was es heißt, einen Befehl zu empfangen und ihn zu befolgen." Die Eingesperrten landen damit exakt im Kern des deutschen Elternterrors, dem Kern des deutschen politischen Terrors im Einzelkörper - genau in dem, was man bekämpfen wollte. Dieser Elternterror, fortgesetzt und im Wechselspiel mit Lehrerterror, Offiziersterror, Blockwartsterror, Terror der Richter und Polizeien aller Sorten ist *die soziale Materialität* am Grund deutscher Körperlichkeit gewesen, *das politische Horror-Syndrom* selber, und nun, Vorschrift bis in die letzte Zeile, oder, wie sie auch sagen, bis zum letzten Atemzug.

„ti - du weisst nicht, was ein befehl ist. sonst hättest du gemacht, was du jetzt allerdings sofort machen wirst: was der befehl wollte. du gehst in eine andere zelle, um die symbiose aufzulösen. um von disziplin nicht länger nur zu reden.

du weisst, draussen hätte dein verhalten bedeutet, wir trennen uns von dir. denn

wenn einer einen befehl durchzuführen vielleicht mal nicht in der lage ist - es wenigstens versuchen kann er immer. du willst nicht, was sonst ist es? (...)

also werde mal erwachsen, ohne dich dabei aufzuführen, als wäre jemand anderes als der staat - wenn man unter erwachsenen emanzipation, selbständigkeit, kollektivität versteht - dein feind. (...) erinnere dich: als du angefangen hast, bist du aus genau so einer ecke gekommen, die du dir jetzt in deinem trakt - und das ist, was man verachtet - eingerichtet hast, eine schnecke mit dem haus auf dem rücken. ist es das, was du willst? "
- Gudrun Ensslin an Ilse Stachowiak, 8.10.76.

'Werde mal erwachsen', und 'Mama ist dein Freund' (nicht *der Staat*); Es gibt fast keinen Brief, durch den dieser Ton nicht durchgeht. Zwar wird gesagt: der Befehl komme aus dem Kollektiv, aber das Kollektiv, und das ist der zweite Horror-Punkt, wird immer gedacht wie *ein einziger* Körper. Die Inhaftierten, obwohl sie voneinander getrennt und isoliert sind, vielleicht auch gerade deswegen, reden immer, als wären sie ein einziger zusammenhängender Über-Leib. Wenn ein einziges Glied davon, eine Hand, ein Haar, was anderes macht, ist der Gesamtzusammenhalt dieses Körpers bedroht. Keiner darf abhauen, panische Angst, daß einer weggeht, abspringt, etwas anderes denkt, nicht mehr mitmacht, Hungerstreik aufgibt. Panische Wut und Draufschlagen, wer etwas anderes auch nur andenkt, wird behandelt wie ein Teil des eigenen Körpers, das sich selbstständig machen will, also bestraft werden muß. Das ist zwar ein altes deutsches Gruppenterror-Syndrom, wie Wolf Biermanns Lied über die Westflucht von Robert Havemanns Sohn Florian demonstriert: *Abgang ist überall*, der Abgegangene ist nun „hinüber, enfant perdu", und, in der nächsten Zeile ist er ein (früh) Gestorbener schon: Weggang = Verrat = Abfall in den Tod. Das wird zum Zentralgestus der Briefe. Als Horst Mahler im Gefängnis Abweichungen von der allgemeinen RAF-Linie unternimmt (er ist einer der wenigen, die das durchgestanden haben), schreibt Holger Meins über ihn:

„die gefangenen, die in der raf organisiert waren, haben eine ratte weniger und ihr eine ratte mehr, der herr mahler hat sich selbst den papierhut aufgesetzt. als revisionist, kolonial-herr, schleimscheisser und marxausbeuter wird er sich demnächst wohl irgendein parteibuch zulegen und irgendein eingetragener verein ein neues starobjekt besitzen. die schlitzaugen, nigger, vietcongs, feddayins und alle rothäute wünschen ihm eine gute fahrt zur hölle, eine gesegnete mahlzeit + allen bullenratten gute verdauung." (5.6.74)

„schlitzaugen, nigger, vietcongs, feddayins und alle rothäute" sind automatisch (und völlig unsinnig) dem eigenen Körper einverleibt; der Genosse von gestern: Ratte, das *Fremde*. Besonders schlimm, wenn die 'Abweichung' an einem selber aufzutauchen droht, das 'Weichwerden'; dann scheint dieser merkwürdige Begriff des 'inneren Schweinehunds' durch, der zu bekämpfen sei, auch so ein Typ, den die faschistischen Elternhäuser und Lehrerschranzen (Ex-Offiziere) dauernd auf ihren Zungen wälzten; bei den Frauen gibt es die parallele Selbsteinschätzung über ihr (schwaches) Geschlecht-steil: „bürgerliche votzenpanik + geschleime, arztpigblick, der sich nicht ändert - hat im kampf nichts zu suchen und ist mit kampf nicht zu vereinbaren." - schreibt Ingrid Schubert, über sich selbst, 23.10.74.

Das nächste ist das 'Ticken'. Es gibt kaum zehn Seiten in diesem Brief-Konvolut, wo noch argumentiert wird. Dafür: „kapier das endlich!" „tick mal!":

„warum hört man denn von dir nie nix? ist dir alles selbstverständlich klar oder was? es kann dir doch·nicht entgangen sein und war ja oft genug gesagt - 'zugefaulte fressen' usw. - , dass das kollektiv von jedem FORDERT, dass er mitdenkt, mitdisku-tiert, mitmacht, bestimmt usw. tick mal! in der iso ist die schreibmaschine DAS produktions- und kommunikationsmittel." (Holger Meins, 29.9.75)

„wir können nicht unterdrückt werden, wenn wir nicht aufhören zu denken und zu kämpfen. wenn du sagst, du kannst den hungerstreik nicht, hast du praktisch schon auf-gehört. warte, wieso kapierst du nicht deine situation? kapier das, was da jetzt nach allem auch und gerade an dir hängt." (Ulrike Meinhof, 11.10.74)

„wir haben uns an deiner votzigkeit zu fragen, ob du nicht länger kämpfen wolltest oder ob du nicht getickt hast." (Andreas Baader, 12.75)

„denn hilde hatte ja offenbar noch getickt: eskalation." (Andreas Baader, 10.74)

„ein grund der entpolitisierungsscheisse bei euch ist sicher, dass ihr die dimension nicht tickt, die der prozess seit fünf jahren hat. (...) der bewaffnete kampf ist der opera-tor des ganzen imperialistischen prozesses in der globalen defensive - das muss man schon mal ticken - also: sich erarbeiten + erkämpfen und immer, täglich, andauernd." (Ulrike Meinhof, 7.10.75)

Eskalation. Tick, Tick, Tick: ...„das muss man schon mal ticken", und hundert Stellen mehr, Baader hat das Wort in einem Zurechtweisungsbrief an eine Mitgefangene gleich

fünf mal: „dass du das tickst oder kaputtgehst" (12.75). Wer das nicht tickt, tickt nicht richtig. Tick mal, check mal, tick nochmal, wenn du's noch nicht hast: Wer eine Sekunde vor oder nach geht, muß umgetickt werden, aber nicht mit einer Argumentation, sondern mit dem Schraubenzieher. Und heißt im Grunde immer: Du hast sie ja nicht alle, wer nicht tickt wie ich/wir, ist falsch eingestellt = verrückt. Das ist umgedreht der Vorwurf, der aus der Bevölkerung den Radikalen gegenüber gemacht wurde/gemacht wird: Ihr seid ja *verrückt,* Ihr gehört eingesperrt, in die Klapsmühlen oder vor einen Gewehrlauf, Lager, Euthanasie, KZ, weg. Genau dasselbe Zwangsmodell, aber mit revolutionärer, ideologischer Unterfütterung, tick das mal, stell mal deine Birne richtig ein, wirf die unmaterialistische Scheiße da raus, entscheiß deinen Kopf, dann wirst du sehen, wo's langgeht.

Zwar tickt im 'Ticken' sprachlich vieles: Verstehen, die Uhr, Funktionieren, einen Tick haben und auch die Zeit-Bombe - also etwa die Rede: 'die Widerstands-Bombe tickt auch im Knast, jetzt tick-versteh doch, daß du nicht deinen Einzel-Tick weiter pflegen kannst, sonst ticken wir nicht im Gleichklang, sonst kann die Bombe zur Sprengung des Schweine-Knastsystems nicht hochgehen' - aber das Dominante, das mir beim Lesen wieder den Magen rumdreht, ist das Zwangssystem des Abweichungsverbots in fast allen Äußerungen der Eingesperrten. Als wäre der Geist ihrer Elterngeneration, dem sie hatten entkommen wollen, gebündelt in sie zurückgeschlüpft in einer umgedrehten Exorzierung, als wären ihre Körper, vom Hunger und Durst ihres Streiks ausgezehrt, über alle Maßen geschwächt, nicht mehr in der Lage gewesen, dem deutschen Horror, der am Grund ihres Wesens abgespeichert lag, länger einen Widerstand entgegenzusetzen, als wäre er über sie gekommen, aufgejagt von Injektionen der Bundesstaatsanwalt und des BKA, und sie zu Puppen konvertiert, die, wie in einem Film von Jürgen Syberberg, die verhaßten Grundlagen der eigenen Geschichte ausspucken.

Ein vergleichbarer Terror der inneren Organisationsstrukturen von den Freikorps über die SS bis in die RAF, irgendwo dazwischen die stalinistischen der DDR und anderer realsozialistischer Gebilde - gleich in diesem Punkt: der 'Abweichler' (der Anders-Ticker) ist das Totalschwein und gehört ausradiert. Die '68er-Rebellion war in ihrem Kern eine Revolte gegen dieses Prinzip. Daß es auch in ihr selber wirksam war, war vielen dunkel bewußt, nicht nur vielen Frauen. Wozu sonst überhaupt Revolte - wenn nicht auch

gegen Teile 'des Selbst'?

„Dumme Nazi-Kälber wählen ihre Schlächter selber" - das hatten wir gesehen; aber was ist mit den dummen Kälbern der 'Linken'? Da heißt es Heroismus, Brechtsche *Maßnahme*, revolutionäre Disziplin, und ist Unsinn aus Gruppenphantasien: 'Abstrakte Politik', Gespensterpolitik. Sie wird gemacht aus einem Mangel an wirklicher Abstraktionsfähigkeit (= kritischer Selbstwahrnehmung) und wirklicher Abgeschnittenheit von den politischen Abläufen. 'Die Welt entzieht sich', und wehe einer sagt da: kümmert mich nicht.

Ich hatte dazu eine Bob Dylan-Zeile im Ohr, seit 1967 schon ...„It's Alright, Ma, I'm Only Bleeding" ...die Strophe vom Typ, verkrüppelt von der Gesellschaft, der nicht aus seiner Klemme heraus will oder kann, „but rather get you down in the hole that he's in". Das habe ich massenhaft um mich herum gesehen in den 70ern: Leute, für die das Herstellen von 'Gleichheit' darin besteht, einen ins Loch runterzuziehen, in dem sie selber sitzen. Durch Vorschrift, und *no politics*.

Die abstrakte Identifikation so vieler 'radikal Fühlender' mit der RAF konnte nur aus diesem Grund so funktionieren: weil da null Politik war, keine einzige formulierbare Forderung außer 'zur Waffe greifen', 'Kampf' und 'Durchhalten', und also auch keine mögliche Diskussion darüber. Das eröffnete das Feld für abstrakte 'Symphatisanten', die in 'ihrem Loch' bleiben konnten, indem die RAF das ihre bekam. *Opferung* der RAF = Null Politik plus Giftabfuhr + 1000 Prozent abstrakte Moral (die wurde dann übernommen ins neue Öko-Polit-System als die Idee von der tausendprozentig sauberen Welt).

Aber gab es nicht so etwas wie einen 'gesellschaftlichen Willen' zur Vernichtung der RAF? Doch, den gab es. Zu sehen u.a. am ausgebliebenen Widerstand gegen die gesetzliche Abschaffung von Rechtsstaatlichkeiten, gegen die Behinderung der Verteidigung, etc. Die Zeitungsbilder der Hungerstreikenden ließen keinen Zweifel: „Verrecken!". 'Bevölkerungs-Interviews' im Fernsehn: „Hängt sie gleich auf", „Legt sie gleich um", „Auf der Flucht erschießen" (an diesen Formeln arbeitete ich grade im Freikorps-Kontext; war alles noch da bei 'den Deutschen', oder gleich *wieder da*, und im Fernsehen zu betrachten), das war eine so klare Haltung 'der Mehrheit' und des Staats, daß man eine öffentliche Position gegen die RAF überhaupt nicht beziehen konnte, ohne sich mit dieser Mordlust gemein zu machen. Eben deshalb konnte niemand in einer ruhigen

und selbstgewissen Klarheit sagen, ich setze mich von der RAF ab, weil das gelaufen wäre unter Distanzierung. Natürlich distanzierte man sich nicht. Ich hätte um keinen Preis ein Distanzierungspapier unterschrieben, wie manche Universitätsleute das gemacht haben, um keine Schwierigkeiten zu bekommen. Es war ein sehr effektiver Schachzug des BRD-Staats, überhaupt keinen Zweifel zu lassen, daß man in puncto RAF bis zur völligen Vernichtung gehen würde. An Peter Brückner wurde dies Exempel, stellvertretend für alle Uni-Leute, 'statuiert'.

Ich habe in dieser Atmosphäre, 1977/78, nach Erscheinen der *Männerphantasien*, Radio- und Fernseheinladungen abgelehnt mit der Begründung, ich wollte nicht aus denselben Apparaten zu hören sein, die den ganzen Tag gegen „die Baader-Meinhof-Bande" hetzten, eine Gangstervereinigung, die den Bestand des Landes bedrohe ...diese Art 'abstrakter Verweigerung' vorm 'Öffentlichen' aus abstrakter Solidarisierung mit der RAF (trotz konkreter Gegnerschaft zur RAF), war ein Dilemma vieler 'öffentlicher' Leute, denke ich, jenes Moments.

Das 'Tick mal' und 'Außer uns nur Schweine' der Briefe erscheint mir dennoch als Resultat eines Gruppenprozesses der RAF - nicht nur als Folge des Terrors, der auf die Isolierten niederging im Knast - denn diese Züge sind vorher in ihren Papieren, z.B. *über den bewaffneten kampf in westeuropa*, wo mit dem Mao-Zitat „bewaffneter Kampf als höchste Form des Klassenskampfes" umgegangen wird, als handele es sich um eine Art Kung Fu-Lehre (...höchste Form). Mao hat in der Methode den Weg gewiesen, „den künftig alle revolutionären Bewegungen zu gehen haben", oder, besonders: „Es ist ein großer Fehler, Leute mitreden zu lassen, die selbst nicht völlig entschlossen sind, am Kampf teilzunehmen ...legale Gruppen ...unvermeidlich durchsetzt mit Schwätzern, Angebern und Zauderern ...Habt ihr die Argumente 1-99 widerlegt, erfinden sie das hundertste."[8] Bloß: das „Widerlegen" (1-99 mal) geschah als „Tick mal!"

Der Hintergrund, sehr real: die absolute Verzweiflung aus der Erkenntnis, daß es nichts wird mit einer revolutionären Politik in Deutschland. Man kriegt das nicht hin, die Leute beleben vielmehr ihre KZ-Phantasien bzw. deren Geschichte und wittern Chance auf *Wiederholung*. Ein Radikalismus, der einer bleiben will, kann in der Lage nicht viel anders, als immer abstrakter werden und reinen (d.h. infantilen) Forderungscharakter kriegen. So kommt das irrsinnige Phänomen zustande, daß die schärfsten Revolutionäre re-

den wie brave, gedrillte Kinder von idealistischen Eltern. Ich hätte nicht erwartet, dies in solcher Schärfe und Offenheit in den Briefen am Werk zu sehen. Jan Carl Raspe schreibt, als die Kreislaufprobleme im Hungerstreik gravierender werden: „auch der kreislauf ist eine frage des bewußtseins." Wer richtig tickt, hat kein Kreislaufproblem ...(Sätze, die auch im Umkreis Reichscher Orgasmus-Schulungen gediehen). Was materialistische Politik hatte werden sollen, ist auf den buchstäblichen Kopf gestellt.[9]

So wurde 'abstrakter Radikalismus' auch die Verbindungsform etlicher Artisten Ende der Siebziger mit dem Schicksal der RAF, zu sehen in Filmen wie *Deutschland im Herbst*.

Ich zitiere zu diesem Punkt zuerst ein Interview mit Gerhard Richter, das im *taz journal* zu *20 Jahre Mogadischu* abgedruckt ist. Richters Gemälde-Zyklus zum Todestag von Stammheim - *18. Oktober 1977* - stammt aus dem Jahr 1988, ist also 11 Jahre nach dem Ereignis entstanden. Richter zur Verbindung seiner Bilder mit der RAF:

„Dann wären die RAF-Toten für sie Opfer ihrer Ideologie?"

„Ja sicher. Aber eben nicht Opfer einer ganz bestimmten Ideologie von links oder rechts, sondern von ideologischem Verhalten allgemein. Das hat eher zu tun mit dem immerwährenden menschlichen Dilemma, ganz allgemein: revolutionieren und scheitern..."

„Avantgarde ist ja bezeichenderweise gleichermaßen ein politischer und ein künstlerischer Begriff. Gibt es einen Bezug zwischen der Kunst und dem revolutionären Aufbegehren? Was interessiert einen etablierten bürgerlichen Künstler wie sie an der RAF? Deren Taten sind es doch nicht."

„Doch, die Taten. Weil da jemand mit größter Radikalität etwas ändern will, was man ja nicht nur gut verstehen kann, sondern was man auch als die andere Seite der Medaille ansehen kann: Kunst wird ja auch manchmal radikal genannt, nur - sie ist es nicht tatsächlich, sondern eben künstlich, völlig anders."

„Ist Malerei ein Angriff auf die Wirklichkeit, der Versuch, etwas ganz Neues zu schaffen?"

„Sie ist allerlei. Gegenwelt, Entwurf oder Modell für etwas anderes, Berichterstattung: denn selbst, wenn sie nur etwas wiederholt, kann es Sinn machen."

„Wiederholung, das ist doch im Grunde das Konzept dieser Bilder. Was kann man an der RAF mit Gewinn erinnern?"

„Es kann uns zu neuen Einsichten bringen. Und es kann auch der Versuch sein, zu trösten, d.h., einen Sinn zu geben. Es geht auch darum, daß wir so eine Geschichte

nicht einfach vergessen können wie Müll, sondern versuchen müssen, anders damit umzugehen - angemessen."

„Sind diese Bilder in ihrem Werk etwas Neues? Sie haben bisher nie so gesellschaftlich aufgeladene Vorlagen gewählt, immer neutrale."

„Das stimmt, ich hatte immer eine Scheu vor politischen Themen, vor dem Spektakulären."

„Aber ihr ganzer Zyklus lebt doch vom Spektakulären der Ereignisse."

„Und es ist ja eigentlich das natürlichste der Welt, daß man die besonderen Ereignisse aufgreift. Es wäre doch absurd, wenn gerade das tabu sein soll, was uns am meisten angeht. Dann würden wir ja nur noch Belanglosigkeiten produzieren."[10]

Ich finde in diesem Interview das, was ich 'abstrakten Radikalismus' genannt habe, prototypisch - und jetzt für die Kunst - formuliert. Die Angst, mit der eigenen Produktion in Belanglosigkeiten zu verfallen, nimmt sich einen Komplex wie 'die RAF' zum Sujet aus einer abstrakten Identifikation mit dieser Verfolgung, die Ende der Siebziger passiert - mit dem Tenor 'auch der Künstler-Avantgardist will *Änderungen mit größter Radikalität*'; er ist darin strukturell ein 'Verfolgter' - darin liegt für den Fotografen/Maler Gerhard Richter eine Berührung mit der RAF, mit der er, weder praktisch noch ideologisch, je verbunden war.

Etwas darstellen, was die RAF *gemacht* hätte, kann er aber nicht: Was bleibt, sind die Bilder der Toten selber. Er muß diese Bilder der Toten malen, ihre Schreibmaschine, Plattenspieler, die Zellen, weil was anderes nicht da ist, was die RAF in irgendeiner Weise hinterlassen hätte an konkreter Politik, außer Mord und dem abstrakten 'Tod den Schweinen'. Genau dieser Gestus ist in der Kunst wiederholbar als 'abstrakter Radikalismus', weil die Trennung des Künstlers vom 'politischen Prozeß' dieses Moments und anderer geschichtlicher Momente eine vergleichbar große ist/war. Man hat das große Thema, hat 'die Zeit' sozusagen auf der Palette, und damit Kontakt zu diesem Syndrom, das ich jetzt mit einem Stichwort nur als 'Führungsanspruch der Kunst' umreiße. An Leuten wie Gottfried Benn oder Knut Hamsun oder Louis-Ferdinand Céline oder Ezra Pound für die Dreißiger, Vierziger Jahre, habe ich beschrieben, daß ihre Verbindung mit den Naziführern nicht aus ihrer primär faschistischen oder nazistischen 'Ideologie' herkommt, sondern aus ihrem Führungsanspruch im Artistischen, den sie - bestimmten Qualen im Realen ausgesetzt und in eine Leere katapultiert - dort zu verwech-

seln beginnen mit Führerpositionen im Politischen: und sie nehmen - von gleich zu gleich, von Genie zu Führer, wie sie denken - Kontakt auf mit diesen Führungen.

Was Gerhard Richter in dem Interview formuliert, ist allerdings sehr viel vorsichtiger, hat auch einen 'Führerkontakt' nicht im Sinn - das ist der Unterschied: der 'Kontakt' wird hergestellt nicht mit 'der Macht', sondern mit den Toten, die *eine bestimmte Staatsmacht* angerichtet hat; aber mit 'der Politik' dieser Toten ist Gerhard Richter nicht mehr verbunden als, sagen wir, Gottfried Benn mit der tatsächlichen Politik Adolf Hitlers 1934. Beide verbinden sich abstrakt mit einem *Gespenst.* Ähnliches gilt für den Herbstfilm von Alexander Kluge, Volker Schlöndorf, Edgar Reitz u.a. Mit der konkreten RAF haben alle nichts zu tun, aber einiges mit dem Anspruch, die 'Wirklichkeit des Moments' in den Griff zu bekommen; das 'große Thema' nicht vorbeizulassen, ohne seinen Rocksaum geküßt zu haben: Otto von Bismarck, Helmut Kohl, Alexander Kluge berühren sich auf dieser Ebene; der Künstler katapultiert sich in diese Berührung aber durch nichts anderes als den abstrakten Führungs- bzw. Deutungsanspruch. Das nimmt im Herbstfilm die absurde Form an, daß Gudrun Ensslins Schwester, die Stammheimtoten und der Stuttgarter Oberbürgermeister Rommel mit *Antigone*, ihrem toten Bruder Polineikes und dem thebanischen König Kreon 'analogisiert' werden - nur weil ein paar Stuttgarter Idioten innerhalb und außerhalb von Zeitungen mit der Idee hervorgetreten waren, den Toten von Stammheim die Beerdigung auf Stuttgarter Friedhöfen zu verweigern. Anders liegt Rainer Werner Faßbinders Beitrag zu diesem Film, dazu gleich.

Der Fall aber ist, daß diese Artisten in einer ähnlichen politischen Leere agiert haben wie der, in die die RAF sich am radikalsten manövriert hatte und mit der auch alle anderen Gruppierungen der Siebziger zu kämpfen hatten, - bis auf Teile der Frauenbewegung[11], der Ökologen und Anti-AKWler, die sich gegen die Leere mit 'konkreter politischer Praxis bis zur Halskrause' zu wehren versuchten. Das schien immerhin ein Ausweis des 'Gefülltseins', den konnten Filmemacher, Professoren oder Kunstproduzenten mit Radikalanspruch nicht vorweisen, wie es in Gerhard Richters Klage anklingt, daß 'Kunst' von sich aus nicht radikal sei, sondern eben 'künstlich'.

Dem gesellschaftlichen Moment selber kann man sich, als empfindender Mensch, dabei nicht entziehen: das war der Moment des Zugrundegehens eines (abstrakten) Revolutionsanspruchs im politischen Vakuum der saturierten BRD und der Moment einer

(gar nicht abstrakten) staatlichen Verfolgung, die zuschlug und ihren Sieg feierte als eine Art neuen 'Bundesschwur' der Republik. Vergleichbare Beispiele 'abstrakter Solidarität' mit der RAF aus dem wütenden Bedürfnis heraus, sich nicht gemein zu machen mit der staatlichen Verfolgung waren auch Claus Peymanns Anti-Distanzierungs-Zettel am Schwarzen Brett der Kantine des Stuttgarter Staatstheaters (unter denen die Ordnung Baden-Württembergs erzitterte), Vlado Kristls Gemälde *Die Verhaftung* [zur Verhaftung von Ulrike Meinhof] oder Jean-Marie Straub/Danielle Huillets Film-Widmung für Holger Meins.

Was dabei in Deutschland unter dem Namen 'Herbst' eine besonders hilflose, beinah rilkehaft-melancholische Gruppenphantasie wurde, war ein internationales Phänomen: zu sehen etwa bei Joe Strummer, Sänger von *The Clash,* der sich Ende der Siebziger im T-Shirt mit RAF-Emblem auf die Bühne schleppte (*Rude Boy),* oder die New Yorker *Times Square Show:* „Künstler, die sich als Pseudo-Terroristen zusammenrotteten und mit der Bevölkerung des von ihnen gewählten Schauplatzes identifizierten"[12], wobei der nötige Abstraktheits-Grad in der Tatsache lag, daß es sich um Leute handelte, „frisch von der Kunstakademie und ohne Zugang zu den etablierten Kanälen und Institutionen."[13] In Deutschland wieder 1994, *Die goldenen Zitronen* mit dem Song *6 gegen 60 Millionen,* Platte*: Das bißchen Totschlag.*

Artistischer 'Radikalismus' verklammert sich mit der (scheinbar oder wirklich) schärfsten Form des politischen Radikalismus in einer gesellschaftlichen Gruppenphantasie des 'wütenden Outcasts'. Ziel dabei weniger 'Kunst', als Giftabfuhr, Schuldreinigung. Daß die Artisten dabei gern als 'schärfste Individualisten' figurieren, ist kein Widerspruch; es gibt keine solchen 'Widersprüche' im System von Gruppenphantasien (wie es im Unbewußten keine Verneinung gibt). Sie funktionieren allein durch die Anzahl derer, die sie teilen; dies ist ihr einziges (und ausreichendes) Realitätszeichen.

Das Realitätszeichen 'Maschinenpistole als Waffe' findet sich jedenfalls bei keinem von ihnen. Die tatsächlichen Morde der RAF, das Erschießen von institutionellen Leuten, hat fast jeder Einzelne, der in den siebziger Jahren seinem Empfinden nach Teil *dieser* RAF (Radikale Abstraktions-Fraktion) war, nicht geteilt, außer im Gestus und da keineswegs so heimlich wie das Wort des Jahres 1977 - 'klammheimlich' - es nahelegen wollte. Das Nicht-Mitleid mit Schleyer war eher offen: um den ist es nicht schade, der ist ein Verbrecher, SS-Vergangenheit usw. - solche Gefühle ersetzen aber nicht: Politik.

Die Leichen, die bald zentnerschwer, bleischwer in allen drin lagen, ist man bis heute nicht los, daher ihr *Geistern* zu Jahrestagen.

Im Film vom *Deutschen Herbst* sind die Leichen schon voll entwickelt als veritable Gespenster, Alexander Kluge gräbt, wie er es gerne tut, mit großem Spaten in der deutschen Geschichte, wirft eine Scholle Sophokles zu Rosa Luxemburg, und eine Handvoll Staatsbegräbnis- und Beerdigungs-Doku dazu, dazwischen ein ewig gegeigtes Deutschlandlied und Oberbürgermeister Rommel als Anti-Kreon; beim Wiederanschauen jetzt der deutliche Eindruck: das ist doch ganz und gar durchgeknallt. Da ist nicht Kreon, da ist keine Ensslin/Antigone, das hat überhaupt nichts miteinander zu tun. Da drehen hilflose Leute an einer Sache herum, die weder die ihre ist noch war, strampeln sich ab im Raum einer verwahrlosten Geschichte und ziehen an den Haaren herbei, was dort herumtaumelt, von Griechen bis Mogadischu, dazwischen Biermann als linker Staats-Pastor in Stuttgart, bloß weil man - und deshalb ist Biermann da richtig - sich 'das schuldig' ist als radikaler Großartist: vorm Auge nicht des Jüngsten, aber des Zeitgerichts. Am Schluß dann Joan Baez mit *Nicola and Bart*, völlig behämmert.

Anders Faßbinders Auftritt, seine Reaktion auf die Nachricht vom Tod der Stammheimer Gefangenen. Faßbinder antwortet mit seinem Körper. Daß ein spezifisches deutsches Körper-System sich in den Terroristen, im Knast reduziert auf sein Familiär-Skelett, zeigte, ist oben ausgeführt. In den zwei Jahrzehnten vor der RAF ist mir dies Körper-System regelmäßig in deutschen Filmen aufgestoßen; ich fand die Filme nicht aushaltbar wegen der Wahrnehmung: es gibt keine Körper darin, in deutschen Filmen läuft kein einziger Körper herum, nur Gespenster, niemand kann gehen, niemand kann sich bewegen, kann sprechen, kann nicht mal so kucken, daß es aussieht wie Kino.[14] Ich sehe das als den in unsere Körper eingegangenen fleischgewordenen Ausdruck des Verschweigens der Nazi-Geschichte durch die Elterngeneration; die Körper der folgenden Generationen tragen so etwas aus, sichtbar, als Hemmung, als Belogenwordensein, als Nicht-Existenz. Wir sind ja als Generation insgesamt von unseren Eltern derartig belogen worden, wie kaum eine Generation vorher, d.h. auch nicht ernst genommen. Diese erfolgreich orgiastisch-verbrecherische Eltern-Generation, die jeden Tag das Lied der ungetrübten Sauberkeit sang, verlangte, daß man fleißig und pünktlich sein, nicht lügen soll und den Gehweg harken am Samstag, dann kommt das Leben in Ordnung,

verarbeitete damit den Mord an den Juden: daß wir als hirnlose Volltrottel aufwachsen sollten, die von Nix nie was merken. Nicht weniges davon *steckt* in unseren Körpern, in unseren reaktionären Ungeschicklichkeiten bis jetzt. Rainer Werner Faßbinder zeigt in dem Film auf die Todesnachricht hin seinen Körper nackt, läuft mit dem Telefonhörer herum, ruft Freunde an, beschreibt sein Entsetzen, kloppt sich mit seinem Liebhaber, weil der sagt: „Die müßten eigentlich aufgehängt werden", wie andere auch argumentierten, er zeigt sein Erbrechen, zeigt sein Geheul, wirft einen Zufallsgast aus der Wohnung, zeigt, wie er sich mit seiner Mutter streitet über das, was für sie und die Deutschen 'Demokratie' ist. Das war genau nicht 'abstrakter Radikalismus'. Faßbinder läßt sehen, was man an den Stammheimern, auf schrecklichere Weise, auch sehen konnte, ein bestimmtes Zerreißen seines Körpers. Am Schluß seines Filmbildes bricht er zusammen: er macht damit nicht eine Geschichte *über* die Gefangenen, sondern zeigt sich selber als Agierenden in einer Analogie zu den Toten; in der Situation 'des Zerreißens' befanden sich alle, die in der Nähe des Körpers der RAF ihren eigenen durch die Geschichte trugen, die Geschichte, die jetzt wieder eine *deutsche* geworden war.

Es gibt solche Momente auch in dem Roman *Kontrolliert* von Rainald Goetz; da besteht die Zerreißung darin, daß er für jede Behauptung zur RAF auch die gegenteilige ausspricht. Ich bin Raspe, ich bin nicht Raspe, ich bin radikaler als Raspe und ich bin sein Feind. Die Argumentationen der RAF sind meine, aber ich verwerfe sie vollkommen; die Gegensätze bis zum Äußersten: natürlich muß getötet werden und der bewaffnete Kampf beginnen, auf der anderen Seite aber: was soll der Unsinn des Tötens, ich bin genauso unbedarft wie derjenige, dem ich das Land erklären will; ich weiß es auch nicht, wie das geht. Und es kommt etwas vollkommen anderes heraus als diese tödliche Linearität.

Linie, Einheit. Einheit heißt Tod. Sobald man Leute, Menschen vereinheitlicht, sterben sie. Da ist nichts zu vereinheitlichen, die Differenzierungen sind zu entdecken und zu entfalten, im einzelnen wie in 500 gesellschaftlichen Linien und Gruppen. Wenn jemand vorhin sagte, „wir wollten endlich mal Politik machen" (und gemeint war: Zuschlagen statt Reden), das ist für mich nicht Politik, das ist Zwangssystem, das ist Vor-sich-her-Treiben von Leuten und nützt überhaupt nichts, aber schafft politische Mythen auf der Opferungsebene, wo man immer noch bis heute Schuld abladen kann, latente Schuldgefühle.

Ich nenne ein paar weitere Namen, die gar nicht fallen in der Diskussion 1997, Namen aus denen ein Heinrich Breloer sich kein Fernsehspiel zusammenbrauen kann (bzw. will): Hans-Jürgen Krahl, Bernward Vesper, Rolf-Dieter Brinkmann, drei Radikale, die nicht diese Gewalt-Produktion der Leere machten, sondern versuchten, das was passiert, mit ihren ästhetischen, ihren artistischen oder denkerischen Ansprüchen und Wahrnehmungen zu verbinden. Was sich als zu schwer erwies, jedenfalls zum Verzweifeln ...Bernward Vespers *Die Reise*, die ganze Flucht-Linie der Drogen, weg vom Vater und dessen Nazi-Menschentum. Gerade, weil er mit Gudrun Ensslin verbunden war, taucht er heute kaum auf. Rolf-Dieter Brinkmann: 'Amerika' drinzuhalten - die Nachkriegs-Linke ist aus Amerika gekommen, nicht aus einer Verarbeitung der kommunistischen Linien, das war sekundär, tertiär. Amerikanische Artistik hat uns geboren, niemand sonst. Hans-Jürgen Krahl: in der primitivsten Parole die Funken philosophischen Denkens am Glimmen zu halten, nicht aufzuhören, 'das Schöne' zu ador(n)ieren ...in all den 'Nachrufen' jetzt habe ich Krahl, Vesper, Brinkmann kaum irgendwo auftauchen sehen, auch Goetz nicht, der ja noch lebt, also die Leute, die dies zerreißende Gemisch enthalten, das dann rasiert worden ist in das Loch von 1977/78 rein. Die publizierende Öffentlichkeit will kein Geschichts-Bild, sie wollen Opfer-Altar-Perpetuierung, das geht am besten mit (freigelassenem) RAF-Gespenst. So wie wir ein Gespenst der DDR haben seit 1990 (das wir vorher auch hatten, aber als ein anderes).

Auch in der Folgezeit ist immer da, wo in Deutschland Journalistisches und Artistisches im Politischen zusammenstießen, meist Gespensterhaftes entstanden: Frank Castorffs *Stahlgewitter*-Vorstoß war nichts anderes, Botho Straußens Bockshorngestöße, Wolf Biermann/Alfred Hrdlickas Nürnberger-Gesetze-Gesteche (mit dem Spezialisten für Gespenstertribunale, Henryk M. Broder als Ringrichter), das große Günther Grass-Marcel Reich-Ranicki Showdown (von dubiosester Abstrakt-Radikalität: jagt Auflagen hoch), beim Golfkrieg war es das 'Bellizisten'-Gehacke: Gift floß immer reichlich, reingestochen wurde in die verschiedenen Container, daß es spritzte, - immer Übungen in 'Abstrakt-Radikalitäten' bei tatsächlicher Abwesenheit jeglicher Politik oder dem (unfreiwilligen) Getrennt-Sein von dieser.

Peter Handke, der etwas anderes versucht hat mit seinen Serbien-Artikeln, nämlich ein konkretes Bild des Landes zu liefern in einer Sprache, die nicht journalistisch werden muß 'im Politischen', wurde von allen Gespenstermännern (logischerweise)

geprügelt dafür: weil er nicht zum abstrakten Radikal-Politiker konvertiert ist, sondern
poetischer Schriftsteller zu bleiben versuchte; einer, der nicht vorgab, die Dinge, von
denen ...gerade sehe ich Christof Schlingensief im Fernsehen durchknallen, Gruppen-
phantasie: „Schuldminderung durch unterhaltungstechnische Lebenssicherung sechs
Millionen Arbeitsloser via Revolutionierung des Talkshow-Niveaus" ...*verry rradical!*
...(und Vorsicht!: Pfeiler im Weg!) ...[15]

1 der vorliegende Text basiert auf einem Vortrag, gehalten im *Berliner Ensemble,* Oktober 1997. Für Material und inhaltliche Hinweise danke ich Stefan Schnebel, Jörg Heiser und Eva Grubinger.

2 - Marx wurde entdeckt als *Schriftsteller.*

3 Wie sehr die Bonner Parteien bedauerten, kein Vietnam zu haben, wo sie ihre aufmüpfige Jugend hinschicken und loswerden konnten, stank ihnen aus jedem Knopfloch. Mit uns war »kein Krieg zu machen«.

4 Zum Lachen: das Stasi-Theater hier nach 1990; fast alle Westdeutschen sind ebensolche Staatsschützer, Spitzeltypen.

5 Pieter Bakker Schut, *Dokumente. das info. briefe von gefangenen aus der raf aus der diskussion 1973-77,* Neuer Malik Verlag, Hamburg, 1987

6 Der angeblich Liberalste sprach die entscheidende Formel: man braucht uns nicht zum Jagen tragen

7 in diesen Schriften mit falschem Cover, die in den Buchläden verkauft wurden unter falschem Titel unter dem Ladentisch, weil sie offiziell verboten waren.

8 *Die alte Straßenverkehrsordnung,* Edition Tiamat, S.51, 120f

9 Von Brigitte Mohnhaupt kommt die einzige Äußerung in dem Band, die sich massiv davon absetzt: »es läuft nie so: was ticken und ungebrochen weiter, sondern du begreifst im bruch (und auch im zusammenbruch)«. Und heißt: "halte ich den Hungerstreik durch, halte ich ihn *nicht* durch", *Projekt RAF,* Berliner Ensemble, 1997, S.13; Es gibt solche Abweichungs-Ausbrüche unter den Gefangenen, aber die Kerngruppe packt jedes solche Zipfelchen in den Schraubstock.

10 Interview von Jan Thorn Prikker aus *Parkett,* Nr. 19, Zürich, 1989, nachgedruckt in *taz journal: die RAF, der Staat und die Linke. 20 Jahre Deutscher Herbst. Analysen Recherchen Interviews Debatten Dokumente von 1977 bis 1997,* Berlin, 1997, S. 19

11 - die Baader, als potentielle Politik-Konkurrenz, immer ganz bewußt abgewertet, wenn er »politisches Fehlverhalten« der inhaftierten Frauen demonstrativ (hyperradikal) mit dem Wort »Votze« bedenkt.

12 Lucy Lippard, *Art Forum,* New York, Herbst 1980

13 Sylvère Lotringer, in :Foreign Agent/Kunst in den Zeiten der Theorie, Merve Verlag, Berlin, 1995, S.45

14 Zu den wenigen Ausnahmen davon gehörten gerade Filme von Alexander Kluge

15 ...Im Vortrag habe ich geendet mit dem Versuch, zu zeigen, daß die Wahrnehmung, die von den Artisten u.a. nicht gemacht, bzw. nicht ausgehalten wird, diejenige ist, die Franz Jung in *Der Weg nach unten* und Georg K. Glaser in *Geheimnis und Gewalt* formulieren: das *Hören einer Geschichtsstille,* und die Wahrnehmung des Umstands, geschichtlich *nicht vorgesehen* zu sein. Daraus folgt, politisch, u.a., ein Absehen von der Großstaats-Politik und eine Hinwendung zu politischen Enklavenstaaten, wie Thomas Pynchon sie in *Vineland* beschreibt, oder wie jeder sie hier kennt, der mit einer Künstlergruppe, einer Redaktion, einem Theater, einer Werkstatt-Cooperative oder ähnlichen Vereinen zu tun hat. Das paßt hier nicht mehr hin, und ist nachzulesen in K.T., *Buch der Könige, Bd.2x,* Stroemfeld Verlag, Frankfurt, 1994, S. 774-89, *und Bd.2y,* Stroemfeld Verlag, Frankfurt, 1994, S.588-592

Ann Powers

Selbst ist die Frau
Post-Feminismus und die Erinnerung
an die Frauen der Boheme

Einige Jahre vor Ausbruch des amerikanischen Bürgerkriegs stieg eine junge Frau aus South Carolina, die gerade von einem Aufenthalt in Paris zurückkam, eine Treppe am Broadway Nähe Bleecker Street in New York City hinunter, hob ihre Röcke an und überquerte den sägespanbedeckten Boden. Ihr Name war Jane McElheney, und wenn ihre Eltern nicht gestorben wären, wäre sie wohl jene Jane geblieben, und ihr einigermaßen privilegiertes Leben wäre vielleicht der Gewalt des Krieges zum Opfer gefallen. Stattdessen wurde Jane ungebunden, als sie zuerst als Waisenkind von ihrem Großvater in den Norden mitgenommen wurde, und sie verließ sein Haus so früh als möglich, im Alter von neunzehn Jahren, ohne einen sicheren Ort in der Welt vor Augen zu haben. Ihre Lösung war, sich fest auf ihre eigene Vorstellungskraft zu verlassen. Sie reichte ein paar Gedichte bei einer Wochenzeitung ein, und da sie nun eine begeisterte Philosophin war und nicht mehr irgendeine vagabundierende Südstaatenschönheit, unterschrieb sie mit dem Namen Ada Clare.

Ada Clare bestimmte - im Gegensatz zu Jane McElheney - ihren eigenen Lebensweg. Sie hatte ein paar Vorteile: ein kleines Treuhandvermögen und Augen, die so blau und zerbrechlich waren wie Delfter Porzellan, beides geeignet, ihren männlichen Künstlerbekanntschaften den Atem zu verschlagen. Aber Ada trug ihr goldenes Haar kurz wie ein Junge, und sie ging mit keinem von ihnen eine feste Beziehung ein. Zu der Zeit des denkwürdigen Gangs über jenen Kellerboden hatte sie bereits einen unehelichen Sohn geboren, und sie hatte mit der Zurückweisung des Vaters klarkommen müssen, eines auf arrogante Weise promiskuitiven Pianisten namens Louis Moreau Gottschalk. Ada war eine Frau mit Vergangenheit, beinahe vom Moment ihrer Geburt an.

In Paris - wo sie hingegangen war, um heimlich das Kind zu gebären - entdeckte Ada ein Viertel, wo Frauen und Männer lebten, wie sie wollten, auf der Suche nach einem Leben, das so romantisch sein sollte wie ihre Vorstellung von Kunst. Daß die Männer

meistens die Kunst machten, während die Frauen ihnen als Modelle dienten, ihnen das Essen kochten und nicht selten ihre Miete bezahlten, störte Ada nicht. Im Gegensatz zu den *grisettes* - den armen Arbeitermädchen des Quartier Latin - hatte Ada genug Geld, um solche symbiotischen Liaisons zu vermeiden. Es gab viele von ihnen, während die Beachtung, die ihre leidenschaftlichen und offenen - wenn auch rührseligen - Gedichte bereits erlangt hatten, bewies, daß es zumindest in Amerika nur eine von ihrer Sorte gab.

Ada kehrte nach New York zurück, fest entschlossen, ihr eigenes Quartier Latin aufzuziehen. Aber eine Handvoll Männer war ihr damit zuvorgekommen. Angeführt von Henry Clapp, der ebenfalls kurz zuvor nach Europa gereist war, wollte diese Gruppe von Journalisten, Kritikern und angehenden Schriftstellern der Pariser Kaffeehausgesellschaft nacheifern. Da aber kein Kaffeehaus zur Verfügung stand, ließen sie sich auf einer langen Bank in einer deutschen Bierschänke namens Pfaff's nieder. Herr Pfaff, der einen Sinn für gute Publicity hatte, ließ ihnen so manche Rechnung nach. Es war Pfaffs Boden, über den Ada ging, während sie all ihren Mut zusammennahm. Sie setzte sich auf die Bank und begnügte sich nicht damit, nur zuzuhören und gut auszusehen. Sie redete über Poesie und Moral und über das, was sie in Paris gesehen hatte, bis Clapp und seine Freunde nicht mehr anders konnten, als ihr zuzuhören. Sie mögen vielleicht gelacht haben, aber Ada Clare wurde die erste Königin der Amerikanischen Boheme, die erste in einer lange Reihe von Frauen unter Männern.[1]

Seit Ada Clares Aufstieg hat die Amerikanische Boheme viele Königinnen gehabt. Manche, wie sie, waren zu ihrer Zeit berühmt und wurden später fast völlig aus der kulturellen Erinnerung gelöscht. Andere, wie Emma Goldman, schafften es, in die Geschichte einzugehen. Manche verließen Amerika dafür: Isadora Duncan, Josephine Baker, Sylvia Beach. Einige, von Georges du Mauriers unschuldigem Künstlermodell Trilby bis Truman Capotes urbaner Naiver mit den großen Augen, Holly Golightly, waren fiktive Schöpfungen von Männern. Wieder andere waren reale Frauen, die als Gegenstand der geistigen Schöpfungen ihrer männlichen Freunde berühmt wurden, während ihr eigenes Werk jahrelang unter dem Bett verstaut blieb; die Frauen der Beat Generation neigten besonders zu diesem Schicksal. Aber alle, ob real oder ausgedacht, gefeiert oder vergessen, teilten bestimmte Attribute, die eine neue weibliche Unabhängigkeit in einer Nation zu repräsentieren begannen, in der von Anfang an mit Freiheit das Recht sich neu zu erfinden gemeint war.

Diese Frauen bilden eine Tradition, die dem Feminismus voranging, in seiner Mitte überlebte und ihn heute, zumindest in einigen Szenen, zu überdauern scheint. 'Postfeministische' Revisionistinnen, die die Frauenbewegung ablehnen, weil sie zu dogmatisch und sogar anti-feminin sei, versuchen, ein neues Modell weiblicher Stärke und Selbstbestimmung zu entwerfen. Autorinnen wie Camille Paglia, Katie Roiphie, Lisa Crystal Carver und Rene Denfield, Musikerinnen wie Liz Phair und Juliana Hatfield oder die Redakteurinnen solcher Publikationen wie *Bust* lassen sich dazu herab, für eine Generation junger Frauen zu sprechen, die sich stark und frei genug fühlen, ihren Weg ohne Unterstützung einer Bewegung zu gehen, die sie als überholt betrachten. Diese Frauen sagen, daß der Feminismus sich immer nur mit der Opferrolle der Frauen beschäftigt und damit nur die Ängste der frauen schürt, anstatt sie zum Handeln zu ermutigen. „Viele von uns wollen einfach losziehen, Graffitis sprayen und mit unseren Freunden rummachen, anstatt uns um Unterdrückung Sorgen zu machen," erklärte Lois Maffeo in einem Artikel von 1994 für das Männermagazin *Esquire* [2] , der diese neue Haltung definieren sollte.

Maffeo und ihre Mitstreiter haben allerdings selten oder gar nicht zur Kenntnis genommen, daß ihre eigene Einstellung selber so alt wie der Amerikanische Feminismus ist und sogar gerade als Gegenpart zur Frauenwahlrechts-Bewegung der Suffragetten des 19. Jahrhunderts aufgekommen war. Zwanzig Jahre nach dem Tod von Ada Clare im Jahre 1874 wurde ihr bahnbrechender Stil zur Massenbewegung. Die Inspiration für den neuen weiblichen Bohemismus war Georges Du Mauriers *Trilby,* von *Harper's Magazine* als Fortsetzungroman veröffentlicht. Und das obwohl Trilby, das hinreißende junge Künstlermodell in du Mauriers Geschichte, kaum so etwas wie Selbstbestimmung verkörperte - sie steht den größten Teil des Buchs über unter dem Bann des Hypnotiseurs Svengali (dessen Charakterisierung durch du Maurier ein Paradebeispiel des literarischen Antisemitismus ist). Dennoch hatte Trilby, wie der Kritiker Thomas Beer festgestellt hat, „etwas mit der Unabhängigkeit der Frauen zu tun; das Frauenwahlrecht war mit der Frage der Aktkunst zusammengeraten."[3] Und während die Suffragetten für Tugend und Stimmrecht kämpften, repräsentierte Trilbys freigeistiger und letzten Endes gefährlicher Lebensstil nun eine sexy Form von Freiheit.

Das Phänomen der 'woman adrift', der 'Frau ohne Halt', das dazu führte, daß die Zahl

alleinstehender Frauen in Amerikas Städten sprunghaft anstieg, weil hoffungsvolle Mädchen ohne große Aussichten herbeiströmten, um Arbeit und Abenteuer zu finden, verschmolz mit der bohemischen Mode-Idee, die 'Junggesellin' zu erschaffen, die in ihrer eigenen Wohnung oder zusammen mit einer Mitbewohnerin lebte, Auftragsarbeiten als Modell oder Grafikerin oder Katalogtexterin fand, während sie zu Hause ihre eigene Kunst zu perfektionieren versuchte und zum Abendessen trockenes Brot auf der Herdplatte röstete, wenn sie mal gerade keinen Studenten gefunden hatte, der sie ausführte. Durch die Junggesellin und ihre privilegiertere Mitstreiterin, die geistreiche Dame der Gesellschaft, wurde aus Feminismus Spaß. Die Suffragetten, denen der entschieden unattraktive Spitzname 'Blaustrumpf' nachhing, wirkten im Vergleich wie Hexen. „Die Blaustrümpfe, heimelig, streng, ohne Gefühl und Zärtlichkeit, führten ihren grimmigen Kampf gegen eine althergebrachte Vorstellung, damit die Frauen nach ihnen einmal eine intellektuelle Freiheit genießen würden, die ihren Vorgängerinnen noch versagt blieb", schrieb die Journalistin Emilie Ruck de Schell, in Worten, die jener Kritik ähnelt, die Post-Feministinnen hundert Jahre später anbringen würden. „Die Gesellschaftsdame von heute ... ist Seite an Seite mit den Männern, die ihre Freundschaft suchen, durch das College gegangen. Ihre Schlagfertigkeit und unbefangene Lebensphilosophie kann das Interesse der Tiefsinnigsten unter ihnen erwecken."[4]

Ab der Jahrhundertwende gingen Bohemefrauen und Feministinnen zwei sich überkreuzende, aber letztlich doch getrennte Wege. Die Werte der Frauenbewegung waren gemeinschaftsorientiert und stützten sich auf eine Vorstellung von Tugend, die als christliche begann und über viele Jahre hinweg zu Göttinnenglauben und Anti-Pornographie-Politik mutierte. Der Ethos des Bohemismus stellte Individualismus über alles, und entwickelte sich zum Ideal der freien Arbeit und der freien Liebe der Beatniks und Hippies, der Begründer der modernen amerikanischen Gegenkultur. Die zweite große Welle des Feminimus zu Beginn der Siebziger wurde von Gegenkulturfrauen vorangetrieben, die des Versuchs leid waren, sich in einer Vorstellung von Individualismus wiederzufinden, die von Männern definiert und dominiert wurde. Aber selbst in den glorreichen Tagen dieser Revolution überlebte die Bohemefrau in Figuren wie Germaine Greer und Janis Joplin. Manchmal wurde sie für ihren Unwillen gescholten, sich der Sache der Schwestern zu verschreiben; in anderen Momenten versuchten Feministinnen, sich mit ihr zu versöh-

nen, weil sie ihre Unabhängigkeit über alle ideologischen Differenzen hinweg bewunderten. Und nun ist sie, in einem Moment politischer Orientierungslosigkeit, zurückgekehrt, um ihren Ehrenplatz als die ursprüngliche freie Amerikanerin zurückzufordern. Unklar bleibt dabei bis heute, wie frei sie in Wirklichkeit je war.

Ada Clare war zweifellos nicht die erste amerikanische Frau, die ihre Haare kurz schnitt und es darauf ankommen ließ. Aber die Einzelheiten ihrer Geschichte bilden eine Blaupause für das Leben der modernen Bohemefrau. Sie machte sich die Mobilität, die durch die Industrialisierung und die Entwicklung der modernen Goßstadt entstanden war, zunutze, um sich so verändern zu können, wie es die Umstände verlangten: nach ihrem Debüt im Pfaff's reiste sie nach San Francisco, wo sie für eine Zeit lebte, dann nach Hawaii, wo sie sich in der Aufmerksamkeit des Ministers für auswärtige Angelegenheiten des hawaiianischen Gerichts sonnte, bevor sie wieder nach Kalifornien ging; als ihre Karriere dort stockte, kehrte sie nach New York zurück, wo sie sich schließlich einem tourenden Theater-Ensemble anschloß. Als Schauspielerin wie Autorin entwickelte sie in dem neu enstandenen Freiraum zwischern Hoch- und Populärkultur eine gewisse Berühmtheit. Sie war sexuell freizügig und wurde vom Mainstream der Gesellschaft für ihre angebliche Schamlosigkeit verdammt, während die Vertreter einer fortschritlichen Sexualmoral sie als lobenswertes Beispiel herausstellten. Sie meisterte den Gang auf dem schmalen Grat des amerikanischen Klassensystems: sie hatte ihr Leben mit einigen finanziellen Mitteln begonnen, diese aber im Krieg verloren, und sie kam damit zurecht, indem sie sich Arbeit suchte, anstatt sich in die Obhut eines Mannes zu begeben. Als sie schließlich doch heiratete, wählte sie sich jemand gleichrangigen, den Schauspieler-Kollegen J.F. Noyes. Sie arbeitete bis zu ihrem Tod.

Und ihr Tod machte aus ihr eine tragische Figur, die sie zu Lebzeiten ganz sicher nicht war. Als sie sich 1874 nach neuen Karrieremöglichkeiten in New York umsah, stattete sie der Theater-Agentur Sanford and Weaver's einen Gesellschaftsbesuch ab. Als sie da saß und sich unterhielt, sprang der Schoßhund der Sanfords sie plötzlich an und biß ihr in die Nase. Keiner wußte es, aber das kleine Biest hatte Tollwut. Einige Monate später wurde Ada während einer Tourproduktion des Stücks *East Lynne* verrückt. Sie starb kurz danach in völligem Delirium. Sie war 38 Jahre alt. Walt Whitman, ebenfalls ein regelmäßiger Zecher bei Pfaff's, erklärte: „Arme, arme Ada Clare - ich war unbeschreib-

lich geschockt durch das schreckliche und plötzliche Ende ihre fröhlichen, leichten, sonnigen, freien, lockeren, aber nicht unguten Lebens."[5]

Ihr katastrophales Mißgeschick verlieh Adas Geschichte die nötige Extraportion Pathos, um in die Mythologie Bohemias einzugehen. Viele Frauen, die ihr folgten, fanden ebenfalls ein schreckliches Ende; in den meisten Fällen wurden sie von ihren Lebensumständen auf viel systematischere Weise dort hingetrieben als durch etwas so zufälliges wie einen Hundebiß. Diese späteren Bohemefrauen fingen wie Ada jedoch immer in dem Glauben an, sie wären stark oder besonders genug, um das Schicksal zu überlisten. Das ist die Eigenschaft Adas, die zentral für diese Art weiblicher Unabhängigkeit geblieben ist: sie beruht auf einem Gefühl von Singularität, auf dem Gefühl, nicht wie die anderen Mädchen zu sein. Der Soziologe Cesar Grana nannte Bohemiens die 'Selbst-Exilierten': Diese Rolle einzunehmen, bedeutet für Frauen, die Welt des Femininen abzulehnen. Die bohemistische Frau fühlt sich einzigartig, weil sie nicht in einer Frauenwelt lebt. Sie ist die Ausnahme in einer separaten Zone, die von Männern abgesteckt wurde.

In *Minor Characters*, ihrer berührenden Biographie einer Jugend unter den führenden Köpfen der Beat Generation, zitiert die Schriftstellerin Joyce Johnson einen 'Traumbrief', den Allen Ginsberg vom allerersten Beat-Schrifsteller John Clellon Holmes erhalten haben will, in dem der Meister verkündete: „Die soziale Organisationsform, welche am wahrhaftigsten dem Geist des Künstlers entspricht, ist die Boy Gang."[6] Holmes, der sich eine Tough-Guy Attitude zulegte, mochte Gangs, und Ginsberg mochte auf jeden Fall Boys. Aber der Poet machte hier nicht nur eine persönliche Vorliebe stark. Von Pfaff's Bierschänke über die Büros des Zwanzigerjahre-Sozialistenjournals *The Mass* zur Cedar Tavern, wo Jack Kerouac und Jackson Pollock nebeinander kotzten, den Rock'n'Roll-Parties der Sechziger, wo Groupies bekiffte Musiker bedienten, der Achtziger Jahre-East Village-Kunstszene mit den Stars Julian Schnabel und Jean-Michel Basquiat, bis hin zu den Raveparties, die von den neueren Elektronik-Musikern dirigiert werden, haben Frauen in Bohemia immer genau den überschüssigen Raum eingenommen, den die tonangebenden Männer nicht schon an sich gerissen hatten. Als Begleiterinnen wurde von ihnen verlangt, diese Testosteron-geschwängerten Umgebungen nicht mit zu viel Weiblichem zu belasten. Stattdessen wurden sie in der Regel Tomboys, also jungenshafte

Mädchen, oder eine komische Mischung aus Tomboy und Püppchen, die in Momenten sexueller Anmache oder Gemeinschaftlichkeit ihre Weiblichkeit aufblitzen ließ, aber sich ansonsten wie ein Tomboy benahm, flachbrüstig und mager und immer für eine Schlägerei zu haben.

Ihre Weiblichkeit blieb zwar verdeckt, aber dennoch füllten diese Frauen oft ganz konventionelle weibliche Rollen innerhalb der Gruppe aus. Johnson erinnert an eine Passage aus der Autobiographie von Carolyn Casady, die Anfang der Fünfziger eine berühmte 'Dreiecks-Heirat' mit Jack Kerouac und Neal Casady einging: „Während ich meine Haushaltspflichten erfüllte, lasen die Männer sich Ausschnitte aus ihren eigenen Schriften oder den Werken von Spengler, Proust und Shakespeare vor, begleitet von energischen Diskussionen und Beurteilungen... Ich war froh, ihnen zuhören und Kaffee nachzuschenken zu dürfen. Und ich fühlte mich dabei nie ausgeschlossen. Sie richteten Bemerkungen an mich und schlossen mich in die Gruppe ein: mit Lächeln, freundschaftlichem Tätscheln, der Bitte um meine Meinung oder darum, eine Diskussion zu moderieren."[7] Anders als frühere Generationen von Hausfrauen bekam Carolyn intellektuelle und sexuelle Anregung im Gegenzug für Putzen und Kochen. Aber es wurde auch von ihr erwartet, Kuchen zu backen. Johnson machte einige Jahre später während ihrer wechselhaften Beziehung das gleiche für Kerouac. Ihre beste Freundin Elise Cowen machte die Hausarbeit für den Mann, den sie liebte - Allen Ginsberg, für seinen Liebhaber Peter Orlovsky (der ihr beim Putzen half), Peters Bruder Lafcadio und ihre Liebhaberin Sheila, der sie beibrachte, ein bißchen wie Ginsberg zu sein. Wenige Jahre nach dem Auseinanderfallen dieses Arrangements brachte sie sich um: Sie sprang aus dem Fenster des Appartments ihrer Eltern in Washington Heights.

Vierzig Jahre zuvor hatte die Schauspielerin Florence Deshon Selbstmord begangen: ihr Versuch, mit *The Masses*-Redakteur Max Eastman eine aufgeklärte Beziehung zu führen, war gescheitert, weil er sich nicht binden wollte. In seiner Autobiographie *Love and Revolution* erinnert Eastman sich an eine Auseinandersetzung, die er und Deshon eines Nachmittags führten:

„[Florence] hegte nicht im geringsten den Wunsch, einem Mann ein Zuhause zu bieten, und ich mochte das. Aber ich war nicht darauf eingestellt, wie sehr sie ins andere Extrem verfallen würde. Eines Tages, ich war gerade ganz ins Schreiben vertieft, ging sie in

die Küche, um uns beiden ein Mittagessen zuzubereiten. Weil ich nicht recht weiterkam, stand ich vom Schreibtisch auf, schlenderte aus dem Haus und die Straße ein Stück hinauf, während ich in Gedanken ein Problem wälzte. Als ich nach ungefähr fünfzehn Minuten wiederkam, hatte sie den Herd wieder abgestellt, das Essen noch halbroh, und stand rasend vor Wut im Hauseingang: „Was glaubst du eigentlich wer ich bin, deine Dienerin?" sagte sie. „Denkst du, ich wäre hierhergekommen, um für dich zu kochen, während du durch die Gegend spazierst?[8]

Eastman versuchte Deshon davon zu überzeugen, daß sein unabsichtliches Fernbleiben keine Bedeutung für ihre Beziehung hatte. Aber als er sich schließlich später niederließ, war es mit einer Frau, die sich genauso gern um Haushalt und Garten wie um ihre intellektuellen Interessen kümmerte, die Eastman als 'Spiel' charakterisierte.

Die feministische Historikerin Ellen Kay Trumberger hat die Beziehungen einiger Greenwich Village Bohemiens und ihrer Freundinnen während der Zwanziger Jahre untersucht (darunter auch Eastman und Deshon), und ist zu dem Schluß gekommen, daß diese Paare tatsächlich nach ihren Vorstellungen von Feminismus lebten - allerdings einem Feminismus, der von Männern definiert wurde. Anstatt Frauen vom 'privaten Leben' zu befreien, damit sie öffentliche Identitäten entwickeln konnten, wie es die Feministinnen des 19. Jahrhunderts versucht hatten, ging es den bohemischen Feministinnen um Gleichheit in der intimsten häuslichen Sphäre. Erklärtes Ziel war, eine Balance herzustellen, so daß die Männer daheim aktiver und die Frauen draußen präsenter würden. Aber man nahm wohl an, daß sich solche Veränderungen von selbst ergeben würden, wenn erst einmal das wichtigere Ziel - beiderseitige sexuelle Erfüllung durch tiefe emotionale Bindung - erreicht wäre. Trumberger fand aber heraus, daß die Männer, die diesem Ideal verpflichtet waren, das emotionale Verhältnis offenbar als eine einseitige Angelegenheit ansahen. Sie wollten ihren Frauen gegenüber offen und verletzlich sein dürfen, wenn umgekehrt aber ihre Frauen offen mit ihnen waren, so wie Deshon mit Eastman, zogen sie sich zurück.

Wenn man sich autobiographische Berichte verschiedener berühmter Bohemefrauen anschaut, wird deutlich, daß die gleichen Szenarien immer und immer wieder vorkamen - zwischen Joice Johnson und Jack Kerouac, Mick Jagger und Marianne Faithfull, Kurt Cobain und Courtney Love. Die Männer gaben sich wirklich Mühe anders zu

sein, und das taten auch die Frauen. Aber sie konnten die Verhaltensweisen, die man ihnen beigebracht hatte, nicht durch schiere Willenskraft verändern. Strukturell gesehen blieb die Situation in den meisten Fällen die gleiche: Arbeit und Ego des Mannes blieben im Mittelpunkt, während die Frau herauszufinden versuchte, wie sie sich weiterentwickeln könnte, ohne ihm dabei in die Quere zu kommen. Und falls das Geld nicht da war, um Kinder- und Dienstmädchen anzustellen, mußte sich ja jemand um die Kinder kümmern und das Klo putzen. Diese Rolle aber zu aggressiv zu spielen, sich als Mutterfigur herauszustellen, rächte sich meistens genauso wie Deshons aggressive Weigerung. Die Frau, die Hausmütterchen spielte, wurde oft für eine attraktivere, 'unabhängige', oft jüngere Frau verlassen - bis der betreffende Mann eine komplette Kehrtwende machte, wie Eastman, als er sein passendes Gegenüber fand, oder wie Kerouac, als er sich zu guter Letzt in die Obhut seiner leiblichen Mutter zurückzog.

Von der Bohemefrau wurde immer erwartet, daß sie diese Lücke zwischen Mutter und Muse alleine überwindet. „Auf sie fiel die ganze Last einer unsicheren Stellung in einer sich verändernden Kultur, denn sie verkörperte für sich schon einen Bruch mit der Tradition. Hauptsächlich von ihrer eigenen Vitalität und ihrer Fähigkeit, eine individuelle Lösung zu finden, hing das Gelingen oder Scheitern ihres Wandels ab", schrieb die Soziologin Caroline F. Ware über die Greenwich Village-Frauen, deren Geschichte Trumberger später aufschrieb.[9] Manche Frauen fanden tatsächlich Lösungen, und das sind jene, die sowohl Feminstinnen, als auch Post-Feminstinnen bis heute rühmen. Eine Möglichkeit, die Rolle von Frau und Kumpel zu versöhnen, war z.B., die unterstützende Rolle in eine öffentliche zu verwandeln, was Frauen oft und gut machten. Die wohlhabende Witwe Mabel Dodge, Gastgeberin spektakulärer 'Abende', die die New Yorker Boheme zur Jahrhundertwende bestimmten; Sylvia Beach mit ihrer berühmten Pariser Buchhandlung *Shakespeare and Company* in den Zwanzigern; Margaret Anderson, die 1917 in Chicago die *Little Review* gründete und Ezra Pound und Djuna Barnes veröffentlichte; Hettie Jones, die das kleine Magazin *Yugen* mit ihrem damaligen Ehemann Leroi Jones gründete; Gloria Stavers, die in den frühen Sechzigern aus ihrer Liebe zu Jungs, die in Bands spielten, einen Job machte, indem sie Redakteurin des *16 Magazine* wurde; Tinuviel, die in den Neunzigern das legendäre *Kill Rock Stars* Indierock-Label gründete - dies sind nur ein paar Beispiele von Frauen, die Unterstützungssysteme bil-

deten, die das Vorankommen der Kunst ermöglicht haben.

Männer waren nicht ohne Großmut in ihrer Dankbarkeit gegenüber diesen wichtigen Komplizinnen. Oft jedoch ließ die Sprache, in der sie dies zum Ausdruck brachten, ihre Lobpreisungen in einem seltsamen Licht erscheinen. Lincoln Steffens regte Mabel Dodge dazu an, ihre berühmten 'Abende' zu veranstalten, indem er sagte: „Männer lieben es, bei dir zu sitzen und Selbstgespräche zu führen."[10] Hätte ja sein können, daß sie etwas interessantes zu ihren Monologen beizutragen gehabt hätte. Der Schriftsteller André Chamson, späterer Direktor des französischen Nationalarchivs, rühmte Beachs unternehmerisches Genie in Worten, die er sicher für schmeichelhaft hielt: „Sylvia trug Pollen wie eine Biene," meinte er, „sie befruchtete diese Schriftsteller überkreuz."[11] Wie muß es sich für eine Frau von Beachs Status, die Zensoren und Konkurrenten dutzendweise ausgetrickst hatte, angefühlt haben, mit einem brummenden Insekt verglichen zu werden?

Wenn man einmal von diesen sanften Schubsern zurück in dienstbeflissenes Schweigen absieht, so konnten Bohemefrauen in ihren eigenen Lebensentwürfen wesentlich mehr hoffnungsvolles entdecken als in jenen, die ihnen von den konventionellen Familien zugewiesen wurden, gegen die sie für gewöhnlich rebellierten. Einfach nur an diesen Orten sein zu können, wo Frauen nie ganz Frauen im gewöhnlichen Sinne waren, gab ihnen Hoffnung. Es war diese Hoffnung, die letztlich die zweite Welle der Frauenbewegung in den Sechzigern entfachte. „Nachts blühten wir auf und rannten durch die Gegend," schrieb Johnson über sich und Cowen in den glorreichen Tagen der Beats.[12] Obwohl sie im nachhinein erkannte, wie sie ignoriert und ausgebootet worden war, blieb sie doch glücklich darüber, daß sie die Chance gehabt hatte, etwas anderes als ein nettes Mädchen zu werden.

Als Johnson einmal einen schlechtbezahlten Job bei einem Verlag nicht bekommen hatte, weil sie Jüdin war, malte sie sich ihre Zukunft als süße Rache aus. In *Minor Characters* erinnert sie sich dieser Träumerei. „Eines Tages werden mich die Verleger, die mich als Sektretärin nicht wollten, als Autorin unter Vertrag haben. Als Schriftstellerin werde ich das Leben als mein anderes, unerhörtes Selbst leben, wie Jack und Allen es getan haben. Ich werde es mir zur Aufgabe machen, über junge Frauen zu schreiben, die ziemlich anders sind als die, die Woche für Woche auf den Seiten des *New Yorker* portraitiert

werden. Ich werde über möblierte Zimmer und Sex schreiben."[13]

Sie schrieb tatsächlich ihren Roman, einige Jahre, nachdem Kerouac für immer aus ihrem Leben verschwand. Sie entdeckte ihr unerhörtes Selbst in der Gesellschaft von Männern, aber es bedurfte des Akts des Aufschreibens, um es zu beanspruchen.

Jahre später entdeckte sie durch den Feminismus ein weiteres unerhörtes Selbst: jenes, das die Männerwelt bedroht hatte, das sie zu einem ungleichen Spieler in einer Szene machte, die sie mittrug. Erst als sie diesem Selbst eine Stimme verlieh, kam sie mit sich selbst in Einklang.

Heute sprechen viele junge Frauen wieder im Singular über ihre Macht. Sie kritisieren den Feminismus, der sie zur Anpassung zwingen wolle, in Worten, die von Ada Clare stammen könnten, wie sie über die viktorianischen Suffragetten sprach. „Es könnte ja sein, daß ihr gar nicht so herausragend seid - nicht in Sachen Ideen, Ideologie, Meinung, ganz bestimmt nicht Intellekt, vielleicht sogar nicht mal in Sachen Kleidung", schrieb Adia Mivons Anfang der Neunziger in dem Fanzine *H2So4* spöttisch über ihre feministischen älteren Schwestern. „Wer möchte weiterhin eine 'Bewegung' oder 'Disziplin' voller Urteile fällender, selbstbezogener und engstirniger 'Feministinnen' aufbauen, die anderen im Namen von 'was für Frauen am besten ist' Vorschriften machen? Ich nicht, Schwestern, ich nicht."

Frauen wie Mivons erkennen zwar an, daß sie den Bemühungen ihrer Mütter viel verdanken, die sich für die Veränderung der sozialen Strukturen, in denen sie an die Peripherie gedrängt wurden, eingesetzt haben; aber sie wollen jetzt einfach direkt ins Zentrum. Wie die Bohemefrauen früherer Zeiten wollen sie sich frei bewegen. Bleibt nur die Frage: Werden die individuell handelnden post-feministischen Frauen in der Lage sein, die grundlegenden Errungenschaften der Frauenbewegungen zu sichern und auszubauen? Vielleicht wird die neue Bohemefrau triumphieren und uns in ein neues Zeitalter grundsätzlicher sozialer Mobilität für alle führen. Sie sollte sich dabei allerdings ihrer Schwestern von Ada Clare bis Joyce Johnson erinnern, die herausfinden mußten, daß 'allein' oft ein einsamer und gefährlicher Ort ist.

1. Albert Parry, *Garretts and Pretenders: A History of Bohemianism in America*, 1960, Dover Publications, New York, S. 14-37

2. *Lock Up Your Sons - the 21st Century Woman is in the Building*, by Tad Friend, *Esquire*, Februar 1994, S. 47

3. Parry, S. 105

4. *Is Bohemianism a Failure*, von Emilie Ruck de Schell, in *On Bohemia*, hg. von Cesar und Marigay Grana, Transaction Publishers, New Brunswick, New Jersey, 1990, S.709

5. Parry, S. 37

6. Joyce Johnson, *Minor Characters*, Washington Square Press, New York, 1983, S. 83

7. Johnson, S. 94

8. Eastman zitiert in: *Feminism, Men, and Modern Love: Greenwich Village, 1900-1925*, von Ellen Kay Trumberger, in:
Powers of Desire: the Politics of Sexuality, hg. von Ann Snitow, Christine Stansell und Sharon Thompson , Monthly Review Press, New York, 1983

9. Caroline F. Ware, *Greenwich Village 1920-1930*, Houghton Mifflin, New York, 1935, S. 258.

10. Grana, S. 519

11. Chamson zitiert von der Princeton University Library Catalog Website, *Sylvia Beach Papers*, www.princeton.edu

12. Johnson, S. 263

13. Johnson, S. 105

Eri Kawade/James Roberts

Stille Post
Soziale Hierarchien und telematische Freundschaft

Wie schon verschiedentlich festgestellt worden ist, haben sich die Kommunikations-
mittel in den letzten zwei Jahrzehnten außerordentlich vervielfacht, und nie waren sie
leichter zugänglich. Mobiles Telefonieren ist mittlerweile beinahe umsonst und der
Markt dafür ist gesättigt, während in puncto elektronischer Kommunikation anfängli-
che Befürchtungen über den endgültigen Ausschluß derer, die sich Kauf und Unterhalt
eines Personal Computers nicht leisten können, zumindest teilweise abgeschwächt wor-
den sind, weil unter 'Randgruppen' wie Obdachlosen oder Öko-Aktivisten ein großes
Bedürfnis herrscht, eine technische Marginalisierung abzuwenden. Im Mainstream läßt
sich ebenfalls eine allgemeine Erleichterung des Zugangs zu Online-Medien beobach-
ten, ob durch das Aufkommen der Internet-Cafés oder durch Online-PCs in Video-
theken und vielen öffentlichen Kulturinstitutionen. Der unvermeidliche Zusammen-
schluß der nächsten Generation digitalen Fernsehens mit irgendeiner Form von Inter-
netzugang (praktisch jeder Haushalt im Westen hat Fernsehen) und Tony Blairs Ver-
sprechen, daß jedes Schulkind eine E-mail-Adresse haben wird, lassen darauf schließen,
daß die nächste Generation zumindest den freien Zugang zum Internet für selbstver-
ständlich halten wird und ihn auch benutzen kann - selbst wenn die Eltern dazu nicht
in der Lage sind. Aber wie jeder weiß, der schon einmal Leuten im Zug oder im Bus bei
völlig überflüssigen Handy-Anrufen zugehört hat (besonders beliebt: im Büro Bescheid
sagen, daß man gerade *im* Zug oder Bus ist), oder sich stundenlang durch Schichten von
Junk-E-mail (oft von temporären Internet Café-Accounts verschickt) oder Usenet-Spam,
also unerwünschte Werbemail (oft von temporären Internet Café-Accounts verschickt),
graben mußte: Zugang und Erreichbarkeit *an sich* ist nicht der Schlüssel zur Kommuni-
kation.

Es hat schon viele markige Kommentare zu den eigentümlichen Eigenschaften von
E-mails und Usenet-groups gegeben, aber sie zeigen wohl tatsächlich auf sehr plastische

Weise die Grundsätzlichkeit einiger Unzulänglichkeiten der Kommunikation, mit welchen Mitteln auch immer die Menschen versuchen mögen, sie zu überwinden. Tatsächlich verschärft und verstärkt das Internet einfach viele dieser Probleme. Eine der bemerkenswertesten und bis dahin unbekannten Eigenschaften ist der seltsame Ton sowohl von E-mail als auch Usenet-Sendungen. E-mail ist nicht einfach eine Weiterführung früherer Methoden der Korrespondenz: im Gegensatz zum Briefeschreiben ist es kaum kontemplativ und reflexiv, und es gibt kein Gefühl von Berührung, von Handschrift oder einer Spur der Person, die die E-Mail geschickt hat. Vielleicht auf Grund dessen, was die meisten Leute mit Keyboard und Monitor assoziieren, fehlt E-mail jedwedes Gefühl von Intimität - es macht einen großer Unterschied, ob man ein paar Worte auf die Rückseite einer Postkarte kritzelt oder die gleichen Worte als E-mail-Botschaft tippt. Eine Postkarte vermittelt Greifbarkeit und den Eindruck eines Verlaufs - sie ist physisch von den Händen des Schreibenden zu den Händen des Empfängers bewegt worden, und wurde wahrscheinlich am Ort der Absendung hergestellt. E-mails zu verschicken ist dagegen mühe-, umstands- und formlos, und das Erscheinungsbild ist abhängig vom Betriebssystem, der E-mail-Software und den geladenen Schriften des Empfängers. Es ist erschreckend einfach, durch E-mails mißverstanden zu werden, weil Ton und Betonung durch die falsche Vorstellung von Unmittelbarkeit, die das Medium vermittelt, verschluckt werden - man geht davon aus, daß der Empfänger dem Gedankengang des Schreibenden folgt, oft, weil dieser auf eine frühere Nachricht antwortet, die er gerade gelesen hat, die aber womöglich Tage oder Wochen zuvor abgeschickt worden war und längst aus der Erinnerung des Empfängers verschwunden ist. Eine E-mail zu verschicken erscheint so leicht im Vergleich damit, einen Brief zu schreiben, eine Briefmarke draufzukleben und ihn einzuwerfen, und vielleicht liegt es daran, daß die Illusion von Direktheit und Transparenz der Kommunikation entsteht.

Diese Probleme erscheinen auf Usenet in verschärfter Form. Bei E-mail gibt es zumindest bestimmte Modelle - Brief, Fax, Telegramm - die langsam an eine neue Form der Kommunikation angepaßt werden. Was im Fall von Usenet einem Modell am nächsten kommt, ist die Vorstellung von Tausenden von Leuten, die in einem großen Saal stehen und sich gegenseitig anschreien, während sie zeitweise überhaupt nicht darauf hören, was irgend jemand anderer sagt. Usenet ist ein Kommunikationsmodell

des 'einer-an-viele' bzw. 'viele-an-einen', das im realen Leben nicht vorkommt - einmal abgesehen von Debatten im Britischen Unterhaus. Die Tatsache, daß Usenet-Mitteilungen zu machen so ähnlich ist, wie ein E-mail zu verschicken, führt dazu, daß sie die gleiche Illusion von Unmittelbarkeit und die gleichen Vieldeutigkeiten im Ton mit sich bringen. Während diese Vieldeutigkeiten bei E-mails ausgeräumt werden können und die Korrespondierenden sich meistens gut genug kennen, um die Bedeutung zu erraten, wird eine Usenet-Sendung von Hunderten oder Tausenden gelesen und auf die unterschiedlichsten Arten interpretiert werden. Das mehrfache Wiederzitieren von Zitaten aus ursprünglichen Nachrichten und der zitierten Antworten auf sie - das 'Nesting' - verkompliziert die Sache noch weiter zu einer Art Stiller Post, die oft in völligem Mißverstehen mündet: Jemand wird z.B. als Täter ausgemacht und mit Flame-Mails bombardiert für ein Vergehen, obwohl er in Wirklichkeit selbst nur geantwortet hatte. Usenet scheint weniger mit nüchterner Information als mit der Neuformierung eines wesentlich älteren Zeitvertreibs zu tun zu haben: Klatsch.

Eine weitere soziale Konvention, die im Usenet verstärkt wird, sind hierarchische Strukturierungen. Das scheint um so klarer zu werden, je spezialisierter die Gruppe ist. Wenn man zwei zufällig ausgewählte Beispiele aus entgegengesetzten Extremen des Spektrums vergleicht, *alt.computing.graphics.renderman* und *alt.games.final-fantasy* [wovon erstere sich mit den technischen Aspekten der High-End Software zur Produktion von Disneyfilmen wie *Toy Story* beschäftigt, letztere mit dem Rollenspiel *Final Fantasy*, einem der weltweit beliebtesten Sony PlayStation-Spiele], so werden ähnliche Muster deutlich. Unter dem harten Kern der regelmäßigen Teilnehmer der Gruppe gibt es immer eine oder mehrere Autoritäten, die an der Spitze der Struktur stehen und am meisten 'wissen'. Bei *alt.computing.graphics.renderman* wird dieser Platz von drei Programmierern eingenommen, die mit Disney und Pixar [dem Hersteller von RenderMan] zusammenarbeiten und die diese Position aufgrund ihres technischen Könnens einnehmen. Bei *alt.games.final-fantasy* sind die Qualifikationen willkürlicher: Obwohl hin und wieder ein 'Lord X' oder 'Prince Y' auftaucht, sich zur Gottheit erklärt und versucht, die Newsgroup zu übernehmen, wird jenem Teilnehmer der höchste Status zugesprochen, der das obskurste Wissen über die undurchsichtigsten Details des Spiels hat. Wo diese

Position der Autorität geteilt wird, vertritt jede Figur einen bestimmten Nebenzweig des Wissens - ein Nebenzweig, der speziell genug sein muß, um den Status der anderen nicht zu gefährden. Teilnehmer, die weiter unten in der Hierarchie stehen, ordnen sich ständig auf unterschiedlichste Weise dem Status dieser Figuren unter und verstärken ihn so. Neulinge, die höflich Fragen stellen, deren Beantwortung für reguläre Leser der Gruppe auf der Hand liegt, werden an frühere Beiträge jener verwiesen, die an der Spitze der Pyramide stehen. Neulinge, die solche Fragen unhöflich oder ohne angemessenen Respekt stellen, werden lächerlich gemacht. Und wehe dem, der es wagt, die Spitzenposition der Newsgroup-Hierarchie einnehmen zu wollen, ohne sich zuvor seine Sporen verdient zu haben, denn er soll in die ewige Vergessenheit 'geflamed' werden! Tatsächlich wird die Attraktivität dieser Führungspositionen deutlich an den Dingen, die Leute anstellen, um sie zu erlangen - das Fälschen von E-mail-Adressen und Erfinden elaborierter Identitäten von Profis mit 'Insider-Informationen' ist eine beliebte Methode, um sofort Usenet-Credibility und den damit einhergehenden Status zu erlangen. Und natürlich können viele, die im realen Leben nur davon träumen können, 'wichtig' zu sein, auf Usenet mit ein wenig Hingabe diese Träume in jener Gruppe von Leuten verwirklichen, deren Respekt der jeweilige Aufschneider sich ersehnt.

Wenn man sich die Entwicklung einer Newsgroup anschaut, so fallen einem vergleichbare Situationen ein, die des öfteren in kleinen Gruppen innerhalb von Büros oder unter Stammgästen von Kneipen und Bars vorkommen. Oft definieren einzelne Mitglieder ihre Stellung über ein Spezialwissen oder sogar ein Hobby: Herr X weiß alles über Autos/Angeln/Multimedia PCs, und falls du als Gruppenneuling irgendetwas in diese Richtung sagst, wird Herr X wie der Blitz zur Stelle sein, um seine Autorität anzumelden, die von seinen Kumpanen bestätigt werden wird. Will man als Neuling von einer solchen Gruppe anerkannt werden, so muß man diese Autorität anerkennen und sein eigenes, nicht-konkurrierendes Wissensgebiet einbringen. Im täglichen Leben dient dieses Verhalten und diese hierarchische Gruppenbildung den Individuen dazu, sich die Welt in verdauliche, überschaubare Happen zu zerlegen, um sich darin ein Plätzchen zu sichern. Während in großen Metropolen wie Tokio oder London die Bedrohung urbaner Anonymität zunimmt und das Gefühl individueller Verortung im Umfeld schwächer

wird, so daß die Leute versuchen, die Stadt in kleine Nachbarschaften zu zerteilen und darin Plätze zu finden, wo sie 'Stammgäste' und als Individuen anerkannt sind, stellt das Internet eine unvorstellbare Erweiterung dar, um sich darin zu verlieren. Entsprechend übernehmen die Leute die Verhaltensmuster und Gruppensozialisierungen, über die sie sich im täglichen Leben definieren, ins Usenet. Der Hauptunterschied ist aber, daß viele der im realen Leben geltenden Konventionen des sozialen Austauschs nun nicht mehr anwendbar sind - man kann so widerlich, rücksichtslos und streitsüchtig sein wie man will, solange die schlimmste Konsequenz der Verlust des Internet-Accounts ist und nicht ein Schlag ins Gesicht. Mit der stark zunehmenden Zahl von Internet-Providern und der Möglichkeit, die Identität in fünf Minuten zu ändern, ist das kaum eine Schranke für Aggressionen.

Besonders negative Beispiele dafür finden sich konkret bei manchen Subscribern, die ihre tiefsitzenden Vorurteile auf eine Weise zeigen, wie sie es in der Realität wahrscheinlich nie täten. Etwa in übertriebenen Formen von Territorialismus („Du mußt ein Dorfdepp sein, ich sehe doch an deinem Provider, daß du aus Mississippi bist") und offenem Nationalismus. Letzteres kann man leicht an den Beschimpfungen erkennen, die jeder erhält, der es wagt, eine nicht-englische Message an eine Newsgroup ohne Ländercode zu schicken, die deshalb von wie vielen jugendlichen Amerikanern auch immer als exklusives Territorium der englischsprechenden Welt angesehen wird - will heißen, Amerikas und dieser anderen Länder, an deren Namen sie sich gerade nicht erinnern können. Das ist der beunruhigenste Aspekt der Gruppenkommunikation im Internet: Daß eine eigene Identität und sowohl Verortungs- als auch Wertvorstellungen anscheinend nur durch den Ausschluß und die Verunglimpfung jener geschaffen werden können, die nicht Teil der Gruppe sind. Das spiegelt letztlich nur wieder, was in der realen Welt passiert; aber die Extreme, zu denen es in der elektronischen Kommunikation getrieben wird, legen nahe, daß die Sehnsucht nach einem festen Platz in der Welt stärker als je zuvor ist und daß die Kluft zwischen den Hoffnungen der Menschen und ihrer realen Situation immer größer wird.

„Natürlich geht's ums Geld, aber... jeder will etwas wert sein, und mit Sex ist es am einfachsten, weil es aufregend ist, wenn andere dich begehren, weil das heißt, daß du einen

Wert als Mann oder Frau hast. Wenn du dich mit Fremden per *Tele Kura* [Telefon-Dating] unterhälst, Verabredungen machst und dich fragst, was das für eine Person wohl sein wird, und du diese Person dann siehst, kurz bevor du sie kennenlernst, dann ist das der aufregendste Moment. Hat man sich erstmal getroffen, geht's schnell zur Sache, aber der Moment kurz vorm Zusammentreffen verspricht die meisten Möglichkeiten...“[1]

Schon vor einiger Zeit wurde der Beeper bei japanischen Teenagern ein unerläßliches Accessoire. Dadurch konnten sie jederzeit und überall mit ihrem Freundeskreis in Verbindung stehen. Bald wurden die Beeper von billigen Funktelefonen mit geringer Reichweite und dem digitalen Handy abgelöst, das sich zugleich auch rasend schnell bei den Untervierzigjährigen zum privaten und geschäftlichen Gebrauch verbreitete. Wenn man schon mal mit einem mobilen 24-Stunden-Kommunikationsgerät ausgerüstet ist, ensteht schon ein Bedürfnis, es zu benutzen, bevor man sich die Frage stellen muß, ob man es überhaupt braucht - ob man jemanden zum Reden hat oder nicht, ob man ein Thema hat oder nicht. Falls nicht, kann man sich einfach jeden Partner und jedes Gesprächsthema aussuchen, indem man sich beim Tokioter Magazin *Ja-mar* persönliche Rufnummer und Info von jemandem raussucht: „Beru-tomo ['Beeper-Freunde'] gesucht: du kannst mich rund um die Uhr anbeepen.“ (Rubrik Mobiltelefone; Kommunikationsstamm: weiblich, 18, freeta [Jobberin, Freelancer]).

Ja-mar ist auf seinen ungefähr 200 Seiten vollgestopft mit Botschaften, die zu potentiellen Begegnungen mit Fremden führen. Man kann hunderte andere treffen, die Kommunikation in jeder Bedeutung des Wortes wollen. Oft ist die Zielgruppe einer Anzeige auf ein bestimmtes Kommunikationswerkzeug eingeschränkt. Manche wollen Freunde, mit denen sie ausschließlich via Beeper kommunizieren - und sich nie von Angesicht zu Angesicht begegnen -, während andere spezifizieren, welches Telefonsystem oder welche Software benutzt werden muß, um süße Bildchen zusammen mit Voice- oder Mail-Nachrichten durch Mobiltelefone zu schicken. Diese Form der telematischen Freundschaft mag die angemessenste für Drei-Minuten-Sentimentalitäten sein - wir wissen alle, daß wirklich Aufregendes sowieso nicht länger dauert. Der Durst nach Verbindungen ist allerdings nicht auf jene beschränkt, die nur ein telematisches Privatleben wollen.

Nach seiner Gründung 1995 erreichte *Ja-mar* innerhalb weniger Wochen eine hohe Aufla-

ge. Der Verlag brachte daraufhin landesweit mehrere verschiedene, lokale Versionen heraus, und mittlerweile gibt es auch einen eigenen Satelliten-Fernsehkanal. Im Prinzip ist *Ja-mar* ein vierzehntägig erscheinendes Magazin, das Anzeigen für gebrauchte Waren, Kontaktwünsche und zum Informationsaustausch veröffentlicht. Es ist in 20 Rubriken unterteilt, wie z.B. Mode, Musik, Sport, Unterhaltung, Kunst, Parties, Essen und Trinken, Mobiltelefone, Spiele, Haustiere, Gesundheit & Schönheit, Sammeln, Leben, Begegnungen etc. Jede Rubrik ist wiederum in kleinere Gruppen namens *...zoku* [Familie/Stamm] unterteilt, wie z.B. Rockmusik, Reggae, HipHop, Rap, Black & Soul, Heavy Metal, Techno, Europop, Klassik, Jazz, Worldmusic, Japanische Musik aus den Siebzigern, Achtzigern, Neunzigern etc., wie in einem Plattenladen also. Es handelt sich nicht um eine neue Art von Publikation, denn es erinnert an *Loot* in London oder *Junk Mail* in Johannesburg, und *Ja-mar* steht auch mit beiden in Kontakt, um bestimmte Anzeigen weltweit auszutauschen und nachzudrucken. Das besondere an *Ja-mar* ist jedoch die systematische Klassifizierung von Information und die Katalogisierung persönlicher Daten, um die Bedürfnisse des Lesers so schnell wie möglich zu erfüllen: eine kleine Tabelle mit Angaben über Geschlecht, Alter, Beruf, Wohnort, Größe, Blutgruppe und Erreichbarkeit des Inserenten ist an jede Anzeige, unabhängig von ihrem Inhalt, angehängt. Bei vielen Anzeigen ist ein kleines Bild dabei, das das Gesicht des Inserenten oder den angebotenen Gegenstand zeigt. Damit es einfacher ist, die Informationen zu überfliegen, hat jede Rubrik verschiedene kleinere Kategorien und Informationsschlüssel: in der Rubrik Kontaktanzeigen weist der Schlüssel *nai* darauf hin, daß der Inserent wert auf das *nai-men* [die 'inneren Werte', den 'Charakter'] der Kontaktierenden legt, während der Schlüssel *gai* ['Äußeres'] einem das Gegenteil sagt - die Person möchte jemanden treffen, der der Beschreibung im Anzeigentext entspricht. Andere wiederum zeigen mit anderen Schlüsseln ihre Präferenzen, wie z.B. Ort, Beruf, Hobby usw.

Auf den Seiten von *Ja-mar* herrscht ein unausgesprochener Konsens, der letztlich die Norm darstellt: Information ist nutzloser Müll, wenn sie nicht sofort abrufbar ist, und deshalb muß jeder Gegenstand - egal, welcher - einem gleichförmigen Standard angepaßt werden, ob es nun eine Freundin ist oder ein Computerspiel, das nicht mehr hergestellt wird. Man wird ermutigt, die Blutgruppe eines Fremden zu überprüfen (um darauf zu schließen, welchen Charakter er hat), damit man entscheiden kann, ob man sein gebrauch-

tes Faxgerät kaufen will oder nicht. Um Antworten auf eine Anzeige zu bekommen, kann man unter fünf Methoden wählen: Direkter Zugang [Antworten per Telefon, Brief, E-mail etc.], *Ja-mail* [Briefe über die Redaktion], Quick Mail [eine schnelle Version von *Ja-mail*], *Ja-matteru* [ein Postfach, das man vom Verlag mietet] und *Ja-matteru Plus* [eine besondere Version von *Ja-matteru*, bei der man eine Message aufnehmen kann, die sich die Interessenten dann telefonisch anhören können].

Aber welche Art von Information müssen die Leser eigentlich aus so einem Magazin so dringend bekommen? Wie systematisch die Information auch strukturiert ist, die eigentlichen Anzeigentexte führen die Kategorisierung oft ad absurdum: „Was ist ein Schleppnetz? Welche Sorte Fisch? Kann ich ein Aquarium finden?" (Haustier: Fisch: weiblich, 29 Jahre alt); „Wer kennt einen Zahnarzt, der schmerzfrei.. nein, ohne Angst einzuflößen, arbeitet? Bitte um Hinweise. Ich kann nicht zu Zahnärzten gehen, weil ich mich davor fürchte, daß mein Mund berührt wird. Möchte gerne auch Erfahrungen hören von Leuten, die ähnliche Probleme haben." (Gesundheit & Schönheit: Vermischtes: männlich, 22, studentisch); „Wer kann mir sagen, wie ich das fette Zeug um meine Taille loswerde?" (Gesundheit & Schönheit: Vermischtes: männlich, 15, Schüler); „Süßer jüngerer Bruder gesucht: ich suche nach jemanden, der mein jüngerer Bruder sein will. Du musst zwischen zwölf und achtzehn uns schwul sein, einen Freund haben und deine Blutgruppe sollte B sein. Du solltest vorzugsweise der jüngste Sohn in deiner Familie sein. Am besten bist du kleiner als 170 cm. Ein süßer Junge, scheu und ein bißchen hilflos, der oft das Baby spielt. Ich werde mir deine persönlichen Probleme anhören und dir meine Meinung sagen, wie meinem echten Bruder. Deine ältere Schwester wird dich beschützen." (Kontakte: Vermischtes: weiblich); „Wer tauscht seine *Pri Cla* [aufklebbare Selbstporträt-Fotos, die in der hypermodernen Paßfoto-Zelle *Print Club* gemacht wurden] mit meinen? Ich bin Hausfrau, keine Schönheit, habe nicht viele rare Versionen, ist das okay? Am besten tauschen wir die gleiche Anzahl Fotos aus." (Sammler: Modisches: weiblich, 32 Jahre).

Man fragt sich, ob die Leute, die diese Anzeigen aufgegeben haben, die zu trivial, zu speziell oder zu absurd sind, um ernstgenommen zu werden, überhaupt mit einer Antwort rechnen. Vielleicht tun sie es - obwohl die Anzeigen einem auch wie ein Vorwand

dafür vorkommen, entweder die Zeit totzuschlagen oder die eigene Existenz im Netz-werk von Lesern und Schreibenden unter Beweis zu stellen. Nicht umsonst ist eines der am häufigsten benutzen Worte im ganzen Magazin 'einsam', und viele der Botschaften sind nur verhinderte Einsame Herzen-Botschaften: „Bitte helft! Ich stehe am Abgrund: mir ging's beschissen in letzter Zeit, zu Hause und in der Schule, ich habe echt genug und stehe am Abgrund. Bitte, helft mir." (Leben: Vermischtes: weiblich, 18, Schülerin).

Manche Botschaften schreien es laut heraus, ohne schützende Barrieren der Ano-nymität, mit dem vollen Namen des Inserenten und voller Adresse zusammen mit einem Foto ihres Gesichts. Die Verletzlichkeit eines einsamen Herzens ist ist oft einem landesweiten Publikum voll ausgesetzt, und man fragt sich als Leser, ob der Inserent nicht irgendeiner Sekte in die Hände fallen wird, die vielleicht schon auf dem Weg zu ihm nach Hause ist.

Der Erfolg von *Ja-mar* war wohl vorhersehbar, selbst ohne den Stimmungswechsel nach dem Einbruch der japanischen Wirtschaft, und dieser Typ von Magazin hätte auch schon viel früher produziert werden können. Sein quer durch alle Genre gehender Index vereint alle Typen von Leuten als potentielles Publikum. Obwohl das Magazin damit prahlt, daß es nicht zum Profitmachen oder als Informationsansammlung für die Marktforschung ge-dacht ist, sondern für freien privaten Informationsaustausch, wird es von dem Medien-riesen Recruit herausgegeben und verlängert einfach die erfolgreichen Methoden seiner anderen Magazine für Jobsuche, Wohnungssuche etc. In einem Land mit 120 Millionen Einwohnern ist das Publikum für das Segment 'persönliche Kommunikation und menschliche Beziehungen' enorm groß. Dezentrale Bürgernetzwerke können sich ohne eine solche Mainstream-Publikation weder richtig strukturieren noch ihre Informationen weit genug verbreiten. Dazu kommt, daß das Publikum für diesen Vernetzungsservice eben das der 'einfachen Leute' ist. Die echten *otaku* und manisch Besessenen, oder die, die den Austausch unter Fans suchen, benutzen weiterhin ihre altbewährten Zines oder Spezialpublikationen mit Mini-Auflage. Entsprechend ist es gar nicht so sehr überra-schend, daß in der Kontakt-Rubrik von *Ja-mar* nur der Austausch persönlicher Daten zwischen Heterosexuellen erlaubt ist; alle Anzeigen mit homo- oder bisexuellem Inhalt wurden mit der Begründung aus dem Blatt genommen, es habe in der Vergangenheit 'verwirrende' Erfahrungen für 'gewöhnliche' Leser gegeben.

Wenn man sich *Ja-mar* anschaut, dann scheinen die 'gewöhnlichen' Leute sich nach 'normalisierten und standardisierten' Beziehungen zu sehnen - nach einem Ort, wo sie sich wegen der einheitlichen Atmosphäre relativ sicher fühlen können, so vielfältig das Magazin aufgrund seines Index auch wirken mag. Letzlich stimuliert *Ja-mar* die gelangweilten Nerven in einen halb spannenden, halb bequemen Himmel, in dem man das zwiespältige Bedürfnis befriedigen kann, den unbekannten 'Anderen' zu treffen und doch der Gemeinschaft jener beizutreten, die die eigene 'gewöhnliche' Einsamkeit teilen.

1 Love & Pop, Ryu Murakami, 1996

Eva Grubinger

Sacher Torture

Klaus Theweleit

Remarks on the RAF Spectre
'Abstract Radicalism' and Art[1]

Background 1: the unreal linguistic situation in post-war Germany. The *unreal* per-
ceived by relating your own existence to the existence of adults (= concealers, liars, or-
der-preserving killers), and expressed in the intelligence of the young generation by ma-
king everything spoken into something comic, into jokes and nonsense, or by learning
English as an evasion and a pop language, in short, Elvis Presley and the Absurdists
(Eugene Ionesco, Samuel Beckett) as the *heirs* of your own speech that had fallen silent
vis-à-vis that of the ex- or still-Nazi adults.

In the early sixties the rock eruption seemed to be under control, defused, in its
coffin: a pupate stage for developing the missing share of your *own* life: as a mere fan
(of Elvis Presley, Samuel Beckett, Gottfried Benn, Billie Holiday) it is not possible to
develop a love relationship, for example. Where is your own body?

Background 2: the 1967 group explosion. A public language had to be added that
raised all the sub- and group-languages from the underground, made them speakable.
The impetus came, politically speaking, in 1967 from the languages of marxism, the lan-
guage of psychoanalysis, which was becoming public, the language of developing mili-
tant internationalism (anti-USA/Vietnam), which combined the speech modes of cine-
ma and rock culture: overall the speech mode of a sexualized impertinence that seized
everything. Another major contributor: the pill. Campaigning, happening-like, scienti-
fic, educational, superior, violent, intoxicated, gossipy, conspiring, touching consu-
ming, self-seeking, paranoid, narcissistic, causal, confused, touching, demanding and al-
so desperate languages and modes of speech, fired by the tones of love, broke out and
for the first time created the possibility of a link between your own speech and a public
space: a new kind of reality that you had previously only asserted, sensed, wanted.

Background 3: Marxism became their main language - more precisely: what Reimut
Reiche called 'Jewish-intellectual cant', an "amalgam transformed into spoken language
by young Germans who unconsciously identified themselves with the persecuted and
eradicated Jewish intelligentsia, an amalgam of theoretical linguistic terms all taken from

'Jewish' disciplines: Marxism, psychoanalysis and critical theory" - because they were mutually scorned: language from Marx, language from *sexual* Freud/Reich, language of persecuted Jews could link up with language from Elvis Presley and language from be-bop, language from John Coltrane: they came from equally extraterritorial areas, and were publicly despised languages and sounds, foreign languages, enemy languages, *un-German* languages.

For me this is the core of '68, the basis of what Deleuze & Guattari were later able to call *Mille Plateaux*, 1000 planes, 1000 poles, the emergence of voices from many places where silence had been imposed; a time for swallowing things and juvenile-senile giggling, for 'doing your duty' and looking on (sadly) as the country, like life, dribbled away into the gully of history at a tempo prescribed by parents-school-authority-police and the world of work.

The RAF came from this same generational background, as before it the central group, that determined the political situation in the late 60s, the SDS, the Socialist Federation of German Students. In Freiburg, where I joined the SDS in 1967 - after Benno Ohnesorg was shot dead by the Berlin police, a cue for many people to join - there were just under 30 of us, and there were not many more in other cities, with the exception of Berlin and Frankfurt. The delegates' conference perhaps included 60 official delegates from Kiel, Hamburg, Hanover, Berlin, Göttingen, Frankfurt, Marburg, Cologne, Heidelberg, Tübingen, Munich, Freiburg, those were the main places: perhaps 500 people in 1967. The main task was to enlarge and agitate, convince people, increase, and to do this by being *open*. The ability to sustain any discussion, no matter how crazy it was, came from a feeling of irrefutable new starts, sexual and political: freedom granted by the pill, by the certainty of the sentence *Make Love Not War*, and from the 'right attitude' to Vietnam: pro Vietcong.

The tendency was: the more acutely the matter was 'politicized', the more the diversity of languages suffered: but there was still no sense that group decisions were binding, sections or a minority could deviate. And in those years there were no acceptance criteria for groups either, no tests for new members: all that had been abolished.

But there were exclusions from delegate conferences; the Munich group, dominated by later members of the German Communist Party, and in Berlin the 'Kommune 1' [first famous German commune for free sexuality]; but this exclusion was ignored by most people. Fritz Teufel and Dieter Kunzelmann continued to belong to 'the radicals'.

Rigour lay elsewhere, in the work. Anyone who was in the SDS had to work for it all day in principle, and they wanted to as well, including the nights, if need be. The groups grew correspondingly slowly, one or two more kept coming along, until spring '68, the first major campaign.

Ulrike Meinhof was not part of this development. She was more from the Easter march movement, GDR pacifism and anti-nuclear protest, in other words from the official East German left, and thus from an officially existing language of the left. She had learned to write, with talent, without the language problems described above, so her language acquisition was more 'homogeneous'. And not against a background of university, sexualization, pop and jazz, but a relatively early marriage, two children and: journalism. Her great journalistic moment came in the campaign against the Emergency Powers Act, that was in spring '68. It led to 80,000 to 100,000 people arriving in Bonn to protest against the passing of these laws. The notion of APO - opposition outside parliament - arose from this, largely the fruit of its magazine *Konkret,* - which was then quickly called *Außerparlamentarische Opposition* in all the newspapers - newspapers above all.

The people who were working from inside the SDS were not hostile to the APO concept and what it stood for, but they resisted it to an extent. We felt that it was inappropriate or even unsound competition. This is a point that it is not easy to see from today's point of view, but which I feel is very important: this was a journalist. There were politically active people who moved around the district all day and were doing something entirely different, and their main aim was not to get 100,000 bods to Bonn, people you couldn't organize anyway. We wanted fifteen more people in our group, that would have been fantastic. It was certainly right to agitate against this body of legislation, but no with the illusion that it could be *prevented*; that was impossible, despite 100,000 people in Bonn. OK, you heard Heinrich Böll speaking there and saw Erich Fried laboriously limping along in the crows, and you were pleased to see these faces, but for the situation at the university or for this apprentice groups that had started to form this mass demonstration had something damaging, superfluous about it.

The 'longed-for' effect made rather too great an impact: the groups enlarged rapidly, between 1967 and 1969 there were no longer 30 people there, but 120, and they could not be sensibly integrated into a discussion process. Splitting up into base groups in which the majority of the theoretical and practical work was done helped for a time. But suddenly there really was something that the newspapers had created as an 'APO

spectre': a crowd of politicized people who attended demonstrations, and other left wing occasions and events. There would be 1000 to 2000 people in the street protesting against Vietnam and for Cuba, but the political work or agitation suffered: how do you make people into socialists of a kind that is not dependent on GDR socialism but on the principle of 'pleasure and freedom'. Whether that had to be called socialism . . . right, you tried to grasp Marx, to learn him by heart, to apply and discuss him. But that had its limitations at the point where 'life' began, where love affairs began, where you made music, read[2] and drank. Everything was highly alcoholized, nights were impossible without alcohol, almost no one went to bed before dawn. Give out the flier in the canteen at lunchtime, book counters, meet comrades, sit in the café, talk, develop campaigns, cinema, go to seminars, discuss things there, politicize people, design the next flyer, in between this the relationship discussions, in twos and with several people, and this all took place in a high-spirited mixture of bohemian and political elements. It was impossible for anything like a dogma to develop here, a 'line' that you had to follow, and it was not supposed to develop either.

Nothing of this was fundamentally journalistic, not even the fliers; they always aimed at 'direct action'. There were many comrades that did not even read a newspaper, and no one watched television either: there was no time, and who needed the twaddle on television, or the news. We went to the cinema.

I always thought that the fact that the groups increasingly got involved in campaigns, in the wake of APO, contributed to the destruction of the SDS core groups as 1970 approached. Fighting purely reactively against something that is decided elsewhere, fighting something that cannot be stopped: this means you're running after things all the time, basing your organization on that, organizing coaches, carting people to idiotic places, having a bit of a bundle with the police, then you go home (read about yourself in the paper), and there's something else you've not been able to prevent, this or that law. Journalistic politics: droning on about campaigns is all that journalists can do, getting directly involved in basic political processes, 'abstract mobilization'. I thought that was barmy, but it was impossible to switch off the mechanism (later it led to witless things like the census boycott).

Work with firms was the next complex, as the groups got larger. For a while the many SDS groups meant that IG Metall [trade union of metal workers] weekends and

things like that could be held. Teaching apprentices about Marx as best you could was one thing; but more important was the person who did it. And why did trade unionists want you to turn up, why did the local IG Metall chairman want to have SDS members turning up and carted his apprentices in? Because there was 'something in the air', and it was enormously attractive, enlightened people in these firms wanted to see and hear these university intellectuals; we weren't workers - only a few of us had work experience - but the workers' movement that would have been dead, destroyed by Fascism, then forced out and pushed 'over there' [Eastern Germany] by West Germany, was, remarkably enough, resurrected to a certain extent by these students.

But this work split the SDS into various camps. There was an incredible desire to learn on all sides, but the larger the groups became and the working field expanded into various social spheres, the more necessary it became for many to follow a defined line, for the sake of security about your own behaviour. This kind of life is very debilitating. If you do it for two to three years, a campaigning life that makes excessive demands on you all the time - and that was the kind of time scale we were talking about - you are approaching the threshold of psychological and physical collapse. Many had abandoned their courses anyway, you couldn't become a teacher any more, most left-wing people already had 'a file on them', you knew that the constitution protection people had piles of that stuff, you won't be able to become a teacher or a professor, a civil servant, and so there's no point in getting your degree - even though officially there was no professional debarment it happened, just as we had predicted.

Many decided to leave university so that they could work in firms: they did not want to fall into line with university groups any more. The famous 'main contradiction' became a key notion, the contradiction between work and capital that swallowed everything up. Anyone who did not go along with that - and this happened very quickly all of a sudden - was seen and treated as a non-Marxist; a dogma that called itself Marxist became accepted in that moment in the early sixties.

The SDS dissolved itself in late '69, like a balloon bursting. Some remained at college, others did 'business', they founded parties with 'Communist' in their names, the so-called 'K-Groups'. Others went more or less 'private', worked for themselves or tried to develop some sort of career in other ways. I went into radio for a few years at that time as a so-called free-lance, through a friend, because I was not compatible with the compulsory K-Communism.

Here personal behaviour was the key to the depth of the split: the people who went off and became 'K-Groupers' did not want to know you any more, from one day to the next. 'Comrades', for whom you would have risked everything the day before under some circumstances, e.g. when someone was arrested and was alone: then you attacked policemen, knocked them over, threw them under the nearest hedge, that worked in the first year or two of relative 'police uncertainty'. The same people to whom one had been so closely linked the night, the week before were suddenly 'enemies' - if they had 'founded' something. These 'foundations': we are called the Communist Party now anyway, Lenin's Red Dawn, ML [Marxist Leninist], AO [Communist Party Founding Organisation], I am leader of the ta-ta-ta factory group; if someone asked what sort of a group that was, it didn't exist yesterday: "It did - it's secret, I can't tell you anything about it." And people started to cross the road when you met them.

It sounds grotesque, but things did collapse like in that way. For some in the form of a nervous breakdown because they could no longer stand years of agitated political work, always having to be on top of the theory, and the simultaneous requirement of developing sensible loving relationships, but free sexuality as well - that right to sleep with any woman, the right to sleep with any man, but nevertheless you had to have *a real* loving relationship - lots of people could not survive this in the long term, women usually collapsed over the sexual point sooner than men, men collapsed at other points, perhaps through alcohol, some drank themselves to death, others killed themselves, women as well.

But the 'K-Groupers' tended to collapse as a result of 'reduction': the world was shrinking to a few main trends that did not need to be *perceived* any longer: everything became 'proposition and statute', camouflaged by hyper-activity, obeying instead of thinking, a complete collapse.

More liberated politics went forward elsewhere: anti nuclear power, women's groups, film groups, 'spontaneous' bands; but many of the so-called 'Spontis' were frustrated party Communists . . .

In this situation - and I think its impossible to understand the RAF and its politics without being aware of this background, Ulrike Meinhof emerges from *Konkret*. She is abstract and radical, and finds herself confronted with: nothing. Not the mass move-

ment that she had banged together on her typewriter. She agitates radically in a void, coming across secret societies, splinter groups, individual private lefties or dogmatic party communists, and links up with what is relatively the most militant or anarchic group that is left, the 'department store arsonists' around Andreas Baader and Gudrun Ensslin.

They formed the RAF (the Red Army Faction) to prepare for the 'armed struggle'; it was a shot in the dark. What else could they have done? I think that the political basis that could have presented itself would have been work in the women's movement. But Alice Schwarzer was there, and that was where Meinhof had just come from, from journalism. She had got her separation and divorce from Klaus Rainer Röhl only with difficulty; he was said to have been repulsive, I don't know whether that's true and I'm not going to say anything about it, or about how and why she left the children behind. But anyway she did liberate herself from all this with great difficulty, but did *not* find precisely the thing that she had hoped for from the situation. I think that even the foundation of the RAF was an act of despair in a void, a political void in terms of 'radicalism', which had come into being in the early seventies.

Thus Ulrike Meinhof becomes part of a great reduction movement: the phenomenon that I described as a linguistic explosion had just been taken back in the early 70s. Restricted, melted down to two or three prescribed, almost institutionalized languages, those assessment languages from left-wing institutions. They have to be got into your party paper every week, what the world situation is like, always the same formulations, garnished with a few Mao quotations. Or, in the case of the RAF, how the political struggle, the anti-capitalist armed struggle is going in various areas of the world, with precisely the same kind of limited pronouncements, from South America to Vietnam: enough to drive you mad.

It's not just the languages that had closed down, the streets were closed as well. The very thing that had been gained - the streets, publicity, openness and linguistic diversity on all sides - disappeared into the gutter of history in two, three years. Not completely, as though it had never existed, some people did carry it on, but more privately, or as a kind of nostalgic infantilism. But in the groups that remained publicly relevant, the 'K-Groups' and the RAF, which were shifting towards the centre of the political movement as the remaining 'radical' groups, language and thought became restricted. This led to what I would now call 'abstract radicalism', a radicalism that limited itself to

gestures, claims, demands, revolutionary attitudes broadcast in statements, slogans, but hardly any analysis was carried out. All this laborious work, getting the teeming chaos of reality into sentences that we are even half right, that agreed in some way with what you saw and what you could perceive, was given up. It no longer had a part to play. Things had to 'be right' only in a mindlessly abstract sense. The 'concrete' emigrated from radical left-wing politics (and found a home, for a time, in the women's movement).

And so where could we take our own claims? Most people who worked in the SDS didn't want to stop, they wanted to carry on with what there was, 'K-Groups', the RAF. People tore themselves to bits with the same argument in every commune, every circle: RAF or not RAF, or at least 'K'? Every SDS group had a radicalized South American who knew all about South American guerrilla tactics, so why not try the same thing here? In Freiburg it was an Argentinian, who fulfilled the same role as Gaston Salvatore did for Rudi Dutschke in Berlin. Pairs like this, third world-first world, or vice versa, linked in a fairly symbiotic way and often the driving force in their group, started to get into each other's hair about this point, to fall out. Dutschke had spoken out, quite clearly and rightly as far as I was concerned, against a policy of assassination: he said that there was no point in shooting down one or another of these big political figures, someone else would move into their place, power cannot be grasped in terms of personalities; whether the employers' association is run by this or that person, whether Persia has this Shah or another one, is unimportant. Power is exercised by social groups, industries, economic strata, and they cannot be injured by individual acts of terror, either in bourgeois society or in semi-feudal third world states. This discussion was actually over when the RAF started its campaign of terror. What we called 'revolutionary violence', whether it was in Vietnam, in South America, in Cuba was not in contention here, it was supported unreservedly. It was not a matter of 'no violence', but: no individual assassinations. But from 1972 onwards, the SDS, the security of this political argument, no longer existed. It all had to be explained in the small war bickering of 'the private'.

The RAF as a multiple spectre existed even then: for some it had to serve as proof of

the 'fascist character' of the West German state; a certainty that it was not easy to keep alive after the amnesty for 'criminal offences' in the context of the student movement. For others it was 'proof' that effective resistance was possible: it *works* with guns.

The ferocity and the panicky hate campaign with which the SPD [Social Democratic Party] under Helmut Schmidt and the other Bonn parties reacted to the RAF: as though it was *the Red Army* itself, already 'at the gates of Bonn', gave the spectre the missing impetus to develop its giant quality.

Most of the 68ers shared the view that West Germany would react to a real 'threat from the left' like a continuation of the Fascist state. The Nazi judges had not been replaced, the judicial apparatus had never been combed through, neither had the Nazi administrations, the murder industries had remained unshorn, the banks, the historians and the press had agreed on the great pact of silence about the Holocaust; lies were circulated about the war, the most unwaveringly clean of all the tank drivers was Chancellor. What could be expected there?

Nevertheless most people, alongside their massive rage about the condition of the country, put clear-sighted pacifism on to the scales as well. Our generation was the first non-soldierly one in Germany from time immemorial; and it was not possible to abort us into the gutter of war, which is something that has always been done and continues to be done with 'disruptive youth' in authoritarian societies.[3]

So *don't* join the RAF. Abstractly there was an 'obligation' to pick up a gun and (at least) do something in the international struggles for liberation, Vietnam, Mao . . . "power comes from the barrel of a gun": everyone said this, all the time. In 'abstract' terms I would have tended more towards the RAF than to the 'K-Groups'. I went to a 'K-Group' at first, but my then girl-friend, now my wife, didn't. Groups with orders, hierarchies - that's no good! What was the point of revolting for years if you now join a group that says you have to go to Stuttgart to a firm they want you to go to because something needs 'building up' there, and its all 'top secret'. That was out of the question: an absolute denial of everything that had been tried politically up to then: "Are you out of your mind?"

The RAF side was just as mad: "the guerrilla as a fish in water in our cities" - that would make no one any the wiser: there was no fish water around us, not in any city in Germany, not even in any *district*. At best a few people who would have hidden you (for a

short time). But there were millions of informers for the *Bildzeitung*. [leading yellow press paper, anti-communist]⁴ The Black Forest as a guerrilla base! You only need to go there by car for a day and take a few steps around the place as a non card-carrying game-slayer (or hiking freak) and the foresters will have noticed and reported you. Every walker reports you, in every field, on every hill, just where you're standing, and its no different in the cities if you draw attention to yourself with something 'suspicious'.

And this leads to the next perception: it is not true what people say, what they write, the way in which they agitate, the things they promise themselves, how they want to revolutionize German society, nothing is true, not a word of it is true. Here the justification of the existence of one's own agitating was to be found - I had learned this in previous years - in the fact that what one wrote had *to be right*. That in some way it had to relate to reality, and could not be replaced by statements like "Kill the pigs". Or, for the 'K-Groupers': "We do not need these differentiations". In Freiburg the first thing they did was to sell the whole stock from the left-wing bookshop that had been laboriously built up in the three or four previous years. Everything was flogged off, only Mao was left, along with two or three other texts. They used the money to buy printing presses and printed their magazine and other sheets that always said the same thing, the same pronouncements about a world situation that was new every day.

For me these people were not 'left wing' any longer. These groups acquired fundamentally right-wing organization, both the 'K-Groups' and the RAF, they were identical internally: commando structures. No sign of equality or analysis. Some of them looked away from any reality, others replaced formulae like "away with" with real violence - although it was at the same time always clear to me that violence, conditioned by the Nazi murders, was *the great German problem*: that as someone who wanted freer forms of ways of life had to fight violence here. Violence in Germany is mixed up with Gestapo violence, concentration camp violence, parental terror-violence, that of beating as well as that of hushing things up. "An armed coup in this society?" "Who do you want to kill then?" As far as I'm concerned, nobody.

The 'K-Groups' reduced themselves to nothing over the years by mutual exclusions, until there was no one left, in other words the Stalinist principle of violence. There was a similar process in the RAF: denunciations of people who wouldn't join in

and death threats for deviationists. The letters I have read in the last few weeks[5] show that this principle also extended to themselves, a constant verbal killing within their own numbers.

One could ask oneself when I first developed the notion that there was something right-wing to „K-Groups" - already at that time or only in retrospect. It's not retrospective in tendency, but it is in the way it's formulated. I had decided not to go on with the 'K-Groups' - against all kinds of resistance from within myself. And it wasn't easy. I know a lot of people for whom withdrawing from 'the street' - you couldn't get out into the open air politically any more - actually affected their walking, their legs stiffened up. They couldn't put one foot in front of the other, their whole body was unsure where to go amidst all this collapse. I'm not sure how I would ultimately have made up my mind if my wife hadn't made it up for me. So 'K-Group'/RAF could have meant splitting up with her for me. I didn't want to do that.

In '72, and this was quite something to think about, we decided to have children. We'll leave all these groups, have a family. We gradually started to learn a bit from the old Communist texts. We didn't know anything at all about what I later called the left wing's self-destruction in the thirties, what happened to people like Georg K. Glaser, Jan Valtin, Franz Jung. The fact that 'the comrades' no longer wanted to know you, didn't want to have anything more to do with you, and couldn't, that was nothing new. That was a Communist tradition *as well*. And what the 'K-Groups' were doing became all the more horrendous. Sandpit Stalinism reinvented in the seventies.

You can check that all out in my case from the fact the *Male Fantasy* book appeared in 1977, there's a lot about all this in it, it was written just at the time of all this, parallel with this anti-group process, staying at home, looking after the child, my wife started to work at the clinic, half writing and half childminding, we shared it all out. Time with the child (and then with other children, friends) was finally the thing that most moved us away from political compulsions, gave us another view: a morning at home alone with the child, who was crawling around on the carpet and starting to build up a world for him/herself made us see what nonsense all this 'agonizing' was like nothing else. A different sense of being 'on the left', and it made it even clearer that 'K-Groups' like the RAF were getting further and further away from what I and a lot of other people had developed as 'left-wing' in previous years.

Now it was no longer about developing a life, but the opposite: sacrifices: a point that no one likes to acknowledge in all the political groups, for perfectly understandable reasons. There is this remarkable phenomenon: why did Rudy Dutschke die in the seventies, why did Hans-Jürgen Krahl [one of the leaders of the Frankfurt SDS] disappear - that was a car crash - you could find a few names from every SDS group who left the exposed positions, the courageous positions, stopped making a target of themselves, standing up in halls, speaking, not knowing themselves how to do it, whether they could do it at all, whether they were right to push their views against thousands of shouting people saying: "shut up", who moan in irritation at the word 'Marx' or, even worse, 'Freud'. Freud was the reddest rag of all: when you started to talk to meeting about how to treat a small child's body there was a howl of protest and aversion, what's that got to do with politics! - and then you had to stick to your point, put up with it, get your ideas across: after a time everybody knows you in a university like that, and to an extent in the town's public life as well. These exposed positions are always highly dangerous, for everyone that they attract. Its certainly gratifying to an extent, you can see yourself as a leader and a person of influence, and also as someone who is at a high point as a thinker, speaker or in some other way.

But at the same time you become a "container for poison" - as Lloyd deMause, the New York psycho-historian calls it - with this idea that I find very accurate: both the supporters and all those who look at you in public, tip ('project') certain stuff into you, offload their fantasies, delegate wishes, commissions, bans. You become a carrier of these things, a 'container', indeed, you have to do this and not that, and you're not forgiven if you don't follow these things through. You are constructed in the eyes of others as a certain kind of activist if you attract or arrogate this kind of public position.

Professional politicians don't bother about this, they thrive on it, on the contrary: they can enjoy it, as increasing power or votes. People who are not interested in rising to leading positions, who are much more concerned - put presumptuously - to develop mass, to be part of that, not to sit on pedestals but to start off political initiatives and campaigns, who aim at something like equality, liberated action, put themselves under enormous pressure, they sense the contradiction: they want to disappear as authorities but to have all the weight of leaders. Jean Luc Godard formulated this very pointedly once in the sentence: "Anyone who can speak to more than twelve people is a dictator."

So 'dictator' on the one hand, 'container' on the other, with other people filling you up with poison and wants. This is true of title page people who get on to covers as well. From Diana to whoever - these are always deadly positions. The point is that the poison collections - and this can come about for example through not being able to act, or feeling helpless and shut in, through powerlessness - discharge themselves in a rhythm that Lloyd deMause divides into four phases: at first you're loved as if you were in a marriage, on a "Honeymoon", then cracks start to appear in the picture, the "Cracking Phase", the next is a poison fantasy in the group, it falls apart, whether as a result of (imagined) hostile infiltration, being undermined or even the opponent's real superiority: the "Paranoid Collapse Phase". You can observe this in almost all political groups and also in individual relations. Then in the fourth phase, the "Blackout" there is a militant clash or even an implosion within a group. The leader can survive this if the group 'pulls off a victory'. DeMause describes this process in terms of American presidents, and they always start a war at this point, Grenada, Panama, Carter's helicopter action in Iran, then that doesn't work out and he's voted out of office. For others it does work, and he's re-elected. Or the king or leader commits suicide: if he doesn't manage to channel the quantities of poison that his supporters have dumped on him, to control them, to dispose of them. Then he has to stand down, to sacrifice himself (Nixon/Watergate), so that someone new takes up the position and the group lives through a period of transformation.

This process, especially "Paranoid Collapse Phase" and "Blackout", happened with the RAF for me in 1975-77. A great deal of bad conscience (poison) had accumulated among all those people who had not followed the RAF. It doesn't matter whether this was for the best or the worst reasons, whether it was fear or cowardice - what was important was the feeling of not having done enough, almost all the 'sympathizers' had that. It was expressed in the fact that you had to give abstract support to this group, that seemed to do so much and did it 'for everyone', but in the certain knowledge that it would end in a death, it could only end in a death.

Today I see it as a kind of co-operation: a group that offers itself to be sacrificed in the most radical form of self-presentation, supporters who accept this sacrifice or even demand it (the so-called 'sympathizers'), and thirdly a state or violent police who carry out this sacrifice.[6] Most of the so-called 'sympathizers': intellectuals, artists, university professors had nothing to do with any kind of practical and radical politics. They re-

proached themselves with inadequate 'political practice', they were laden with feelings of guilt (= accumulated poison), and this was all resolved under pressure from a group that presented itself as the only revolutionary one (voluntarily taken on the Jesus, the Cross position) in the form of a German redemption: 'autumn melancholy'. This form of co-operation between political outlawhood that provides the violations and a state that perform the (ritual) sacrifice and a group that (after a great outcry) survives and carries on purified, is model poison container politics as social execution of certain group fantasies (- which appear, incidentally, in all 'camps' of this kind; and it was here among other places that concepts like 'left wing' or 'right wing' started to break up in the course of the eighties).

Entry into the ritual of social sacrifice can be seen in the case of the RAF by examining the analytical quality of their papers. At the beginning there were rudiments of an analytical approach to situations,[7] but very soon there is little other than an argumentative 'emptying out'. In my case I always stopped reading very quickly at the points at which this kind of sentence started to appear: "anyone who does not support us is actually supporting West German state justice, full stop. As you are supporting West German state justice, you are a pigs' faction . . ." that was always there. Later this formula appeared, anyone who does not think like us has "unmaterialistic shit in his head", even in letters from one prisoner to another: "the point is that the situation is different every day and you simply have unmaterialistic shit in your head", as Ulrike Meinhof wrote to Irene Goergens [member of RAF] on 11.10.74.

Prescribing what other people should do and not do - we're in the army and in the *family* - Franz Jung's Mama: but the boy's not playing right, he's not holding the violin right, not looking at the music right. Funnily enough what he is playing is right, but he ought to do it differently. This 'but mummy wants it like that' complex, training in early and late childhood, schooldays, streams out of the pores of all the RAF prisoners. Instructions, directions, guidelines, reproaches, appeals, original mummy and daddy sound, orders. 'You must learn what it means to receive and carry out an order.' With the prisoners land in the precise centre of German parent terror, the heart of German political terror in the individual body - precisely the thing that they wanted to fight. This parent terror, continued and alternating with teacher terror, officer terror, block warden terror, terror from judges and police of all kinds has been *social materiality* at the

bottom of German physicality, *the political horror syndrome* itself, and now, instructions down to the last line, or, as they say, down to the last breath.

"ti - you don't know what an order is. otherwise you would have done what you're certainly going to do straight away now: what the orders said you should do. you are being put in another cell to break up the symbiosis. so as not just to talk about discipline.

you know that outside your behaviour would have meant that we would have to let you go. for if someone is perhaps in a position not to carry out an order - at least he can always try. you don't want to, what else can it be? (. . .)

so grow up, without trying to make out that someone other than the state - if we see adults as emancipated, independent, collectively aware - is your enemy (. . .), then remember: when you started you came out of just the same kind of corner that you have set up for yourself - and this is what we despise - in a wing, a snail with a house on its back. is that what you want?" - Gudrun Ensslin to Ilse Stachowiak [members of RAF], 8.10.76.

'Grow up' and 'Mama is your friend' (not *the state*). There is scarcely a letter that does not have this note running through it. It is true that it is said that the order comes from the collective, but the collective, and this is the second horror point, is always seen as *a single* body.

The prisoners, even though they are separated from each other and isolated, or perhaps precisely because of that, talk as though they were a single, coherent super-body. If a single element of it, a hand or a hair, does something different, then the entire coherence of this body is threatened. No one is allowed to run away, panic fear that someone will go off, jump down, think something else, not join in any more, abandon the hunger strike. Panic rage and hitting out, anyone who even starts to think of doing something different is treated like a part of one's own body that is trying to make itself independent and so has to be punished. This is an old German terror group syndrome, as Wolf Biermann's song about Robert Havemann's son's flight to the West demonstrates: *Departure is everywhere*, the one who has gone away is now "over, an enfant perdu", and in the next line he is already someone who has died (early): going away = treachery = departure into death. This becomes the central gesture of the letters. When Horst Mahler [member of RAF] deviated from the general RAF line in prison (he is one of the few who came through it), Holger Meins [member of RAF] wrote about him:

"the prisoners who were organized inside RAF have one rat less and you have one rat more, herr mahler put on the paper hat himself. as a revisionist, colonial master, slime-shitter and marx exploiter he will probably soon get himself some party membership book and some registered association will have a new star object. the slit-eyes, niggers, vietcong, feddayin and all redskins will wish him a good journey to hell, hope that he enjoys his meal + that all bull-rats will have good digestive systems." (5.6.74)

"slit-eyes, niggers, vietcong, feddayin and all redskins" are automatically (and quite nonsensically) assimilated into the body; yesterday's comrade: rat, the *alien*. Particularly bad when the 'deviation' threatens to appear in oneself, 'softening up'; then the strange concept of the 'inner swine' shines through, and this is to be fought, also one of the types that the Fascist homes and teacher lackeys (ex officers) constantly rolled around their tongues; in the case of women there was the parallel self-assessment about their (weak) sexual organ: "bourgeois cunt panic + slime, doctor-pig-look that does not change - there is nothing for that in the struggle and cannot be unified with the struggle." - wrote Ingrid Schubert [member of RAF], about herself, 23.10.74.

The next issue is 'ticking'. There are scarcely ten pages in this bundle of letters that still contain an argument. What you get instead is: "Just get this clear!" "Get ticking!"

"why don't we hear anything from you? is it all supposed to be obvious or what? you can't have missed it and it's all been said often enough - 'rotten gobs' etc. -, that the collective *demands* from everyone that they think along with it, join in discus-sions, decisions etc. get ticking! in iso [solitary confinement] the typewriter is *the* means of production and communication." (Holger Meins, 29.9.75)

"we cannot be suppressed if we don't stop thinking and fighting. when you say you can't join in with the hunger strike you have practically stopped. wait, why can't you understand your situation? understand what you and you in particular are responsible for after all." (Ulrike Meinhof, 11.10.74)

"because you're being such a cunt we have to ask whether you don't want to go on fighting or whether you've just not been ticking." (Andreas Baader,12.75)

"because hilde obviously hasn't been ticking: escalation." (Andreas Baader, late 10. 74)

"one reason for all your depoliticization shit is that you're not ticking in terms of the dimension that the process has taken on since five years ago (. . .)

the armed struggle is the operator of the whole imperialist process in the global de-

fensive - that's just got to tick - so: work things out + fight for them and do it always. daily, all the time." (Ulrike Meinhof, 7.10.75)

Escalation. Tick, tick, tick: . . ."that's just got to tick", and in a hundred other places, Baader even used the word five times in a letter of reprimand to a fellow prisoner: "that you tick through that are you're done for" (12.75). Anyone who doesn't tick that isn't ticking right. Just tick, just check, tick again if you've not got it yet: anyone who's a second slow or fast'll have to have their tick adjusted, but not by argument, but with a screwdriver. And what this basically means is: you haven't got them all, anyone who doesn't tick like me/us isn't adjusted properly = mad. Conversely that's the reproach that the populus used to make about the radicals: you are *mad*, you ought to be locked up, in the loony-bin or looking down the barrel of a gun, camp, euthanasia, concentration camp, away with you. Precisely the same compulsive model, but with a revolutionary, ideological lining, tick through that, get your head right, throw out the unmaterialistic shit, get the shit out of your head, then you'll see what it's all about.

There is a great deal ticking in 'ticking' linguistically: understanding, the clock, functioning, having a 'Tick' (a bee in your bonnet) and also the ticking time-bomb so something like this: 'the resistance bomb ticks in clink as well, so can't you tick-understand that you can't just keep to you own tick, otherwise we won't be ticking in harmony, otherwise the bomb to blow up the pigging clink system can't go off' - but the dominant that turns my stomach over when I'm reading is the compulsory system of forbidden deviation in almost everything the prisoners say. It is as if the spirit of their parents' generation, that they had tried to escape from, had slipped back into them in a bundle in a kind of reversed exorcism, as though their bodies, worn out by the hunger and thirst of their strike, weakened beyond measure, were no longer in a position to resist the German horror that was stored up at the bottom of their being, as though it had come over them, aroused by injections from the public prosecutor and the Federal Criminal Investigation Agency, and had made them into puppets who spit out the hated basis of their own story as if in a Jürgen Syberberg film.

A comparable terror in the inner organizational structure from the volunteer corps via the SS to the RAF, and somewhere in between is the Stalinist one in the GDR and other real-socialist structures - the same in this point: the 'deviationist' (who ticks diffe-

rently) is a total pig and deserves to be eliminated. Fundamentally the '68 rebellion was a revolt against this principle. That it was also effective in this case as well was dimly perceptible to many, not just to many women. What else is the point of a revolt - if not against part of 'yourself' as well?

"Stupid Nazi calves choose their own butcher" - we'd seen that; but what about the stupid left-wing calves? There it's called heroism, Brecht's *Maßnahme* [measures taken], revolutionary discipline and is nonsense arising from group fantasies: 'abstract politics', spectre politics. It comes about because of a lack of real ability to be abstract (= critical self-perception) and really being cut off from political processes. 'The world is withdrawing', and woe betide anyone who says: don't care!

I had a line of Bob Dylan in my ears about this, from as early as 1967 . . "It's alright, Ma, I'm only bleeding" . . . the verse about the guy who doesn't want to or can't get out of his fix, "but rather get you down in the hole that he's in." I saw masses of that around me in the 70s: people for whom creating 'equality' meant pulling you down into the hole that they were sitting in. Through instructions, and *no politics*.

The abstract identification of so many who were 'feeling radical' with the RAF could only function like that for this reason: because there was no policy, no single demand that could be formulated other than 'taking arms', 'struggle' and 'hanging on', and thus no possible discussion about it. This opened up the field for abstract 'sympathizers' who could stay 'in their hole' by giving it to the RAF. RAF *sacrifice* = nil policy plus poison removal + 1000 per cent abstract morality (this was then taken over into the new eco-polit-system as the idea of the 1000% clean world).

But was there not something like a 'social will' to destroy the RAF? Yes, there was. It could be seen among other things in resistance to the legal abolition of constitutional state matters, against prevented defence etc. The newspaper pictures of the hunger strikers left no doubt: "Die a miserable death!"

'People interviews' on the television: "String them up", "Bump them straight off", "Shoot them as they run away" (I was working on these formulae in the context of the volunteer corps; it was all still there for 'the Germans', or *back again*, and could be seen on television), this was the clear attitude of 'the majority' and of the state, that you couldn't take up a public position against the RAF without joining in with this lust for

murder. For this precise reason no one could say calmly and with self-confident clarity that you were detaching yourself from the RAF because that would have counted as distancing. Of course one did not distance oneself. I wouldn't have signed a distancing paper at any price, as a lot of university people did, so that I wouldn't get into any difficulties. It was a very effective chess move by West Germany to leave absolutely no doubt that they would go so far as complete annihilation as far as the RAF was concerned. Peter Brückner was 'made an example' of this, as a representative of all university people.

In this atmosphere, in 1977/78, after *Male Fantasy* appeared, I turned down all sorts of radio and television invitations on the grounds that I did not want to be heard on the same sets that were stirring up hated all day long against the "Baader-Meinhof gang", a gangster organization that was threatening the existence of the country . . . this kind of 'abstract refusal' of the 'public' as an act of abstract solidarity with the RAF (despite concrete opposition to the RAF) was a dilemma at that moment, I think, for a lot of 'public' people.

But the 'just tick' and 'all pigs but us' syndrome in the letters does seem to me to be the result of a group process within the RAF - not just as a result of the terror that isolated members were faced with in prison - as these traits can be seen in their papers at an earlier stage, e.g. *about the armed struggle in western europe*, where the Mao quotation "armed struggle as the highest form of the class struggle" is treated as though it was some sort of Kung Fu theory (. . . highest form). Mao's method showed the way "that all revolutionary movements had to follow in future", or, particularly: "It is a great mistake to let people have a say who have not completed made up their minds to take part in the struggle themselves . . . legal groups . . . inevitably full of blabbermouths, boasters and procrastinators . . . Once you have refuted arguments 1-99, they will invent the hundredth."[8] But: 'refuting' (1-99 times) took the form of 'keep ticking!'.

The background, very real: absolute despair arising from the insight that revolutionary politics in Germany will come to nothing. You can't bring it off, people resort to their concentration camp fantasies or the history of them and sense the possibility of *repetition*. Radicalism that wants to remain so cannot do much in that situation other than become more and more abstract and acquire the character of a purely (i.e. infantile) demand. Thus we have the crazy phenomenon that the most extreme revolutionaries talk like the good, well-drilled children of idealistic parents. I would not have expec-

ted to see this so sharply and openly in the letters. Jan Carl Raspe [member of RAF] writes, when circulation problems became more serious during the hunger strike: "circulation is a question of awareness as well." Anyone who ticks properly will not have a circulation problem . . . (pronouncements that also flourish in terms of Reich-style orgasm training). What should have become materialistic policy is literally turned on its head.[9]

Thus 'abstract radicalism' also became the form that connected many artists in the late seventies with the fate of the RAF, to be seen in films like *Deutschland im Herbst*.

At this point I shall first quote an interview with Gerhard Richter that was printed in the *taz journal* on *20 years after Mogadishu*. Gerhard Richter's cycle of paintings on day of death in Stammheim [prison in Stuttgart, specially built for the RAF] - *18 October 1977* - dates from 1988, so was produced 11 years after the event. Richter on the connection of his pictures with the RAF:

"So for you the dead RAF members were victims of their ideology?"

"Yes, definitely. But not victims of a quite definite left- or right-wing ideology, but of ideological behaviour in general. It's more to do with the constant human dilemma, quite generally: making a revolution and failing . . ."

"Avant-garde is significantly both a political and an artistic concept. Is there a relationship between art and revolutionary rebellion? What is interesting about the RAF for an established bourgeois artist like you? It can't be what they did."

"Yes, it is what they did. Because there someone is wanting to make a very radical change, which it is not just easy to understand, but that can also be seen as the other side of the coin: art is sometimes called radical as well, but - it isn't in fact, but it's just art-like, completely different."

"Is painting an attack on reality, an attempt to create something completely new?"

"It's all sorts of things. A counter-world, a sketch or model for something different, a report: because even if it's only repeating something it can make sense."

"Repetition, fundamentally that's the concept behind these pictures. What can we profitably remember about the RAF?"

"It can lead us to new insights. And it can also be an attempt to comfort, i.e. to give it some meaning. It is also about the fact that we cannot forget a story like that, as if it were refuse, but we have to try to handle it differently - appropriately."

"Are these pictures something new in your work? Up to now you have never cho-

sen such socially charged material, always neutral matters."

"That's true, I always shied away from political subjects, from spectacular things."

"But your whole cycle draws its life from the spectacular nature of the events."

"And actually it's the most natural thing in the world that one should take up particular events. It would be absurd if the very thing that affects us most were to be taboo. In that case we would only produce trivial things."[10]

I find the quality that I have called 'abstract radicalism' in this interview, formulated prototypically - and in this case for art. Fear of one's own production declining into triviality chooses a complex like 'the RAF' as a subject as a result of abstract identification with this persecution, the end of the seventies passed - with the slant: "avant-garde artists want *the most radical change possible* as well; in this they are structurally persecuted" - in doing this photographer/painter Gerhard Richter has a contact with the RAF, with which he was in fact never linked, either practically or ideologically.

But he cannot represent anything that the RAF might have *done*: what remains are the images of the dead people themselves. He has to paint these pictures of the dead, their typewriter, record player, the cells, because there is nothing else that the RAF might have left behind in the form of concrete policy, except murder and the abstract 'death to the pigs'. Precisely this gesture can be repeated in art as 'abstract radicalism', because the artist's separation from the 'political process' of this moments and other historical moments is/was comparably great. He has the grand theme, has 'time' as it were on his palette, and is thus in touch with the syndrome that I will now sketch in with a heading only as 'art's claim to lead'. When writing about people like Gottfried Benn or Knut Hamsun or Louis-Ferdinand Céline or Ezra Pound for the thirties and forties I said that their link with the Nazi leadership did not derive from their primarily Fascist or Nazi ideology, but from their claim to lead in artistic matters, which they - exposed to certain torments in reality and catapulted into a vacuum - started to confuse at this point with leadership positions in the political field: and they take up contact - from equal to equal, from genius to leader, as they think - with these leaders.

What Gerhard Richter formulated in the interview is certainly much more cautious, and also is not concerned with 'leader contact' - that is the difference: the 'contact' is established not with 'power', but with the dead, brought about by *a certain state power*; but

Gerhard Richter is no more linked with 'the politics' of these dead people than, say, Gottfried Benn was with Adolf Hitler's politics in 1934. Both link themselves abstractly with a *spectre*. Something similar is true of the autumn film by Alexander Kluge, Volker Schlöndorf, Edgar Reitz etc. None of them have anything to do with the concrete RAF, but something to do with the claim to be getting a grip on the 'reality of the moment'; not letting the 'big subject' pass without having kissed the hem of its garment: Otto von Bismarck, Helmut Kohl, Alexander Kluge make contact on this plane; but the artist catapults himself into this contact through nothing other than the abstract claim to leadership or interpretation. In the autumn film this takes the absurd form that Gudrun Ensslin's sister, the Stammheim dead and Manfred Rommel, the mayor of Stuttgart are 'made analogous' with *Antigone*, her dead brother Polynices and the Theban king Creon - just because a few Stuttgart idiots had come up with the idea in and out of the papers of refusing to let the Stammheim dead be buried in Stuttgart cemeteries. Otherwise Rainer Werner Fassbinder's contribution to the film is the same as that.

But the fact is that these artists acted in a similar political vacuum to the one into which the RAF had manoeuvred itself at its most radical and with which all the other groups had to struggle in the seventies - except parts of the women's movement[11], the ecologists and the anti-nuclear power lobby, who tried to defend themselves against the vacuum with 'concrete political practice up to their back teeth'. But that still seemed to be a certificate of being 'full up' that film-makers, professors or art producers with a claim to be radical cannot show, as suggested in Richter's complaint that 'art' is not in itself radical, but just 'artistic'.

But as a feeling person it is not possible to avoid the social moment: that was a moment when an (abstract) desire for revolution foundered in the political vacuum of a saturated West Germany and the moment of a (by no means abstract) state persecution, which hit out and celebrated its victory as a kind of new 'Federal oath' sworn by the republic. Comparable examples of 'abstract solidarity' with the RAF, arising from the raging need not to align with the state persecution also included Claus Peymann's anti-distancing note on the blackboard of the canteen in the Staatstheater in Stuttgart (a great threat to order in Baden-Württemberg), Vlado Kristi's painting *Die Verhaftung* [The Arrest], relating to the arrest of Ulrike Meinhof, or Jean-Marie Straub/Danielle Huillet's film dedication to Holger Meins.

In Germany this became a particularly helpless group autumn fantasy with an al-

most Rilke-like melancholy, but it was an international phenomenon: it was demonstra-
ted by Joe Strummer, for example, singer with *The Clash*, who dragged himself on to the
stage in the late seventies in a T-shirt with an RAF emblem (*Rude Boy*) or the New York
Times Square Show: "artists who ganged up as pseudo-terrorists and identified themselves
with the population of the scene that they had chosen",[12] while the necessary degree of
abstraction lay in the fact that it was about people who were "fresh from the academy
of art and without access to the established channels and institutions".[13] And in Ger-
many again in 1994, *Die goldenen Zitronen* with the song *6 against 60 millions*, record:
Das bißchen Totschlag (That bit of manslaughter).

Artistic 'radicalism' is linked with the (apparent or real) most acute form of politi-
cal radicalism in a social group fantasy of the 'raging outcast'. The aim here was not so
much 'art' as poison removal, purging guilt. There is no contradiction in the fact that
the artists concerned like to present themselves as the 'toughest individualists'; there are
no such 'contradictions' in the group fantasy system (just as there in no negation in the
unconscious). They function simple because of the number of people that share them;
that is their only (and adequate) sign of reality.

But the sign of realty that is a 'sub-machine-gun as weapon' is not to be found with
any of them. The RAF's actual murders, shooting people from institutions dead, was
not shared by almost all the individuals who were part of *this* RAF (Radical Abstraction
Faction) by dint of their sensibilities in the seventies, except in the gesture, and there by
no means as secretly as the word of 1977 - 'numb-secretly' - would suggest. Non-sympa-
thy with Schleyer tended to be open: it doesn't matter about him, he's a criminal, SS
past etc. - but feelings like that are no substitute for: policy. And we have still not got
rid of the corpses today, who soon weighed everyone down, weighing hundredweights,
as heavy as lead, and that is why they *haunt us* on anniversaries.

In the *German autumn* film the corpses are already fully developed as spectres, Klu-
ge digs about, which is something he likes to do, in German history with a big spade,
throws a clod of Sophocles at Rosa Luxemburg, and adds in a handful of state funeral
and burial documentary, and in between the German national anthem played absolute-
ly for ever and Mayor Rommel as an anti-Creon; looking at it again now I have the
clear impression that it does not work on any level. That's not Creon, that's not Enss-
lin/Antigone, they have nothing whatever to do with each other. It's just helpless peo-
ple playing around with something that never is or has been theirs, slaving away in

neglected history and dragging in everything that's staggering around there, from the Greeks to Mogadishu, with Wolf Biermann in between as a left-wing state pastor in Stuttgart, just because - and that is why Wolf Biermann is right here - he feels he 'owes it' as a radical great artist: in the eyes of time, if not of the last judgement. Then at the end you get Joan Baez with *Nicola and Bart*, completely barmy.

Rainer Werner Fassbinder's appearance was different, his reaction to the news of the Stammheim prisoners' death. Fassbinder responds with his body. I have shown above that the terrorists demonstrated a specifically German body-system, reduced to its family skeleton, when in prison. In the two decades before the RAF I regularly came across this body system in German films; I couldn't stand these films because I realized: there aren't any bodies in them, there isn't a single body walking around in German films, only ghosts, no one can walk, no one can move, can speak, can look in such a way that it looks like cinema.[14] I see this as an expression, now part of our bodies and made flesh, of the fact that our parents' generation kept quiet about the Nazis; the bodies of the next generation have to bear that, visibly, as an inhibition, as something they have been lied to about, as non-existence. We as a generation have been lied to by our parents like scarcely any generation before us, and that also means that we have not been taken seriously. This successfully orgiastic and criminal generation of parents, who sang the song of unsullied cleanliness every day, demanded that we were hard-working and punctual, shouldn't tell lies and should rake the path on Saturday, then life would be in order, that would deal with murdering all those Jews: all we needed to do was to grow up as completely brainless idiots, who never notice anything about anything. And there is still quite a lot of this *stuck* in our bodies, in our reactionary clumsiness right down to today. In the film Fassbinder shows his body naked when he hears the news of the deaths, runs around with the telephone receiver, rings up friends, describes his horror, come to blows with his lover because he said "They should have been strung up", just like everyone else, he shows himself vomiting, shows himself crying, throws a chance visitor out of the flat, shows himself quarrelling with his mother about what 'democracy' is for her and the Germans. None of this was 'abstract radicalism'. Fassbinder lets us see, and this was something that one could see in a more horrifying way in the Stammheim prisoners, that his body was being torn up to a certain extent. He breaks down at the end of his film: he is not telling a story *about* them, but shows himself as

someone acting in analogy with the dead; everyone who was close to the body of the RAF and carrying their own body through history, history that had now become *German* history again, was in the situation 'of being torn up'.

There are also moments like this in Rainald Goetz' novel *Kontrolliert*. There the tearing up consists of the fact that for every assertion about the RAF he presents the opposite as well. I am Raspe, I am not Raspe, I am more radical than Raspe and I am his enemy. I argue like the RAF, but I reject them completely; opposites of the most extreme kind: of course we have to kill and the armed struggle has to begin, but on the other hand: what is all this nonsense about killing, I am just as naive as the people I want to explain the country to; I don't know how it works either. And something completely different from this deadly linearity comes out.

Line, unity. Unity means death. As soon as you unite people, human beings, they die. Uniting is not the thing to do, the differences have to be discovered and developed, in the individual as well as in 500 social lines and groups. When someone said earlier "we wanted to make policy" (and what they meant was: hit out and stop talking), that isn't policy for me, it's a compulsory system, it's driving people in front of you and it's absolutely no use, but it creates political myths on the level of sacrifice, where you can still unload guilt today, latent feelings of guilt.

I can mention a few more names that are not heard at all in 1997 discussions, names from which someone like Heinrich Breloer [he made a TV-docu-drama on the 20th anniversary of the Schleyer kidnapping and Mogadishu] cannot put a television play together (or wouldn't want to): Hans-Jürgen Krahl, Bernward Vesper, Rolf-Dieter Brinkmann, three radicals who did not go along with producing this violence in a vacuum, but tried to combine what happened with their aesthetic, artistic or intellectual claims. Which turned out to be too difficult, anyway it caused despair . . . Bernward Vesper's *Die Reise*, the whole flight offered by drugs, away from father and his Nazi humanity. He scarcely crops up today because he was linked with Gudrun Ensslin. Brinkmann: keeping 'America' in - the post-war left came from America, not from developing Communist lines, that was secondary, tertiary. We were born from American artistry, and from nothing else. Krahl: keeping the spark of philosophical thought glimmering even in the most primitive slogan, never ceasing to adore - to adorn - 'the beautiful' . . . in all

the current 'obituaries' I have scarcely seen Krahl, Vesper or Brinkmann crop up everywhere, and not even Goetz, who is still alive, in other words the people who contain this tearing mixture that was then brushed away into the hole of 1977/78. Perpetuation, that goes best with the (released) RAF spectre. Just as we have had a spectre in the GDR since 1990 (which we had before, but a different one).

And spectral things have always come about subsequently where journalism and artistry meet politics in Germany: Frank Castorff's *Stahlgewitter* approach was no exception, Botho Strauss's Bockshorn shots, Wolf Biermann/Alfred Hrdlicka's Nuremberg law stabs (with the spectre tribunal specialist Henryk M. Broder as referee), the great Günther Grass-Marcel Reich-Ranicki showdown (with the most dubious abstract-radical quality: pushes sales up), in the Gulf War it was the 'Bellicist' chopping: poison always flowed copiously, people stabbed so hard into the various containers that it positively spurted out - but all this was exercises in abstract radicality in the actual absence of any policy or an (involuntary) separation from this.

Peter Handke tried to do something different with his Serbia articles; he wanted to deliver a concrete picture of the country in a language that did not have to become journalistic 'in the political', but he (logically) got a lot of stick from all the spectre people: because he did not convert himself into an abstract radical politician, but tried to remain a poetic writer; one who did not pretend that things about which . . . I can see Christof Schlingensief banging on the television, a group fantasy: "reduction of guilt by entertainment-technical life-protection for six million unemployed via revolution of the chat-show level" . . . *verry rradical!* . . . (and be careful! pillars in the way!) . . .[15]

1 This text is based on a lecture delivered in the *Berliner Ensemble* in October 1997, for information materials and hints as regards content I would like to thank Stefan Schnebel, Jörg Heiser and Eva Grubinger.

2 Marx was discovered as a *writer*.

3 You could smell on every buttonhole of the Bonn parties that they deeply regretted that they did not have a Vietnam to which they could send their rebellious youth and get rid of them. "No war could be made" with us.

4 Something amusing: the Stasi fuss here after 1990; almost all West Germans are state protectors just like that, informer types.

5 Pieter Bakker Schut, *Dokumente das info. briefe von gefangenen aus der raf aus der diskussion 1973-77*, Neuer Malik Verlag, Hamburg 1987

6 The one who was ostensibly the most liberal uttered the crucial formula: you do not need to carry us to the hunt.

7 in the writings with false covers that were sold with false titles under the counter in bookshops because they were officially forbidden.

8 *Die alte Straßenverkehrsordnung*, Edition Tamiat, p. 1, 120 ff.

9 Brigitte Mohnhaupt produced the only statement in the book that distances itself significantly from this: "it doesn't work

like that: tick through something and then move on uninterrupted, you understand when things break, and when they collapse completely" And says: "if I go through with the hunger strike, if I *don't* go through with the hunger strike", *Projekt RAF*, Berliner Ensemble, 1997, p. 13; There are outbreaks of deviation like this among the prisoners, but the core group packs any little odds and ends like that into the vice.

10 Interview by Jan Thorn Prikker from *Parkett*, no. 19, Zurich, 1989, reprinted in: *taz journal: die RAF, der Staat und die Linke. 20 Jahre Deutscher Herbst, Analysen Recherchen Interviews Debatten Dokumente von 1977 bis 1997*, Berlin, 1997, p. 19

11 which Baader always quite consciously belittled, as potential political competition, when he demonstratively (hyper-radically) dismissed 'politically incorrect behaviour' by the women prisoners with the word 'cunt'.

12 Lucy Lippard, *Art Forum*, autumn 1980

13 Sylvère Lotringer, in: *Foreign Agent/Kunst in den Zeiten der Theorie*, Merve Verlag Berlin, 1995, p. 45

14 Alexander Kluge's film was among the few exceptions to this.

15 I ended the lecture by trying to show that the perception that artists etc. didn't have, or did not sustain, is the one that Franz Jung formulated in *Der Weg nach unten* and Georg K. Glaser in *Geheimnis und Gewalt: Das Hören einer Geschichtsstille*, and perceiving the fact of *not being anticipated* by history. The consequence of this, politically among other ways, is that people look away from large-scale state politics and turn to political enclave states, of the kind described by Thomas Pynchon in *Vineland* or that everybody here knows who has ever had anything to do with a group of artists, an editorial department, a theatre, a workshop co-operative or similar associations. This does not fit in here, and can be read in K.T., *Buch der Könige, vol. 2x*, Stroemfeld Verlag, Frankfurt, 1994, pp. 774-789, and *vol. 2y*, Stroemfeld Verlag, Frankfurt, 1994, pp. 588-592.

Ann Powers

Her Own Woman
Post-feminism brings us back to the Bohemienne

A few years before the outbreak of America's civil war, a young South Carolina woman just back from a sojourn in Paris descended a staircase on Broadway. near Bleecker Street in New York City, lifted her skirts, and walked across a sawdust-covered floor. Her name was Jane McElheney, and if her parents hadn't died she may have stayed that Jane, her life of modest privilege eventually consumed in the violence of the war. But Jane became untethered, first taken North by her grandfather as an orphaned child, then leaving his house as soon as possible, at age nineteen, with no clear route to a secure place in the world. Her solution was to tie herself to her own imagination. She submitted a few poems to a weekly newspaper, and becoming the ardent philosopher who wrote those poems instead of some wandering Southern belle, she signed them Ada Clare.

Ada Clare, unlike Jane McElheney, determined her own course in life. She had a few advantages: a small trust fund and eyes as blue and fragile as Delft china, both of which made her male companions in artistic pursuit swoon. But Ada wore her golden hair short, like a boy's, and did not settle down with any of them. By the time she took the momentous walk across that basement floor, she had already borne a son out of wedlock, and endured rejection by the child's father, an arrogantly promiscous pianist named Louis Moreau Gottschalk. Ada was a woman with a past almost from the moment she was born.

In Paris, where she had gone to discreetly give birth, Ada discovered a neighborhood where men and women lived as they pleased in pursuit of a lifestyle as romantic as their tastes in art. That the men mostly made the art, while the women served as their models, cooked their meals, and often paid their rent, did not bother Ada. The *grisettes* of the Latin Quarter were poor working girls; Ada had enough money to avoid such symbiotic liaisons. And there were many of them, while the attention her passionate and frank - if maudlin - poems had already garnered proved that, so far in America, there was only one of her.

Ada returned to New York determined to make her own Latin Quarter there. But a bunch of men had beaten her to the task. Led by another recent European traveller, Henry Clapp, this group of journalists, critics, and would-be novelists sought to emulate Parisian cafe society. With no cafe available, they took up residency on a long bench in a German beer hall known as Pfaff's. Herr Pfaff, sensitive to a good publicity stunt, forgave much of their bill. It was across Pfaff's floor that Ada Clare walked, steeling herself. She sat down on the bench, and did not just listen and look pretty. She talked, about poetry and morality and what she'd seen in Paris, until Clapp and his friends could not help but listen. They might have laughed, but Ada Clare became the first Queen of America's Bohemia, one in a long line of women among men.[1]

Since Ada Clare's ascendancy, American Bohemia has had many queens. Some, like her, were famous in their time and later nearly erased from cultural memory. Others, like Emma Goldman, managed to enter into history. Some left America to do so: Isadora Duncan, Josephine Baker, Sylvia Beach. Several, from Georges du Maurier's innocent artists' model, Trilby, to Truman Capote's wide-eyed urban ingenue, Holly Golightly, were fictional creations of men. Still others were real women who became famous as the subjects of their male companions' musings, while their own work stayed tucked away beneath their bedframes for years; the women of the Beat Generation were particularly prone to this fate. But all of them, real and imagined, celebrated and forgotten, shared certain attributes that came to represent a new kind of female independence in a nation where, from the beginning, liberty meant the right to reinvent yourself.

These women form a lineage that precedes feminism, survived in the midst of it, and now, in some circles, seems to be outlasting it. As they reject the women's liberation movement, which they consider dogmatic and even anti-feminine, 'post-feminist' revisionists are attempting to devise a new model of female strength and self-determination. Writers such as Camille Paglia, Katie Roiphe, Lisa Crystal Carver, and Rene Denfield, musicians like Liz Phair and Juliana Hatfield, and the editors of such publications as *Bust* deign to speak for a generation of young women who consider themselves strong and free enough to make their way without the assistance of a movement they consider outdated. Feminism, these women suggest, is all hung up on victimhood, generating fear among women instead of encouraging them to act. "A lot of us just want to go spray-paint and make out with our boyfriends and not worry about oppression,"

explained Lois Maffeo in a 1994 article from the men's magazine *Esquire* [2], that sought to define this new attitude.

What Maffeo and her compatriots rarely if ever acknowledged was that their own stance was as old as American feminism itself, and in fact arose in counterpart to the suffrage movement of the 19th century. Twenty years after Ada Clare's death in 1874, her pioneering style became a mass trend. The inspiration for the new female bohemianism was du Maurier's novel *Trilby*, serialized in *Harper's Magazine*. Although Trilby, the gorgeous young artists' model whose story it told, hardly epitomized self-determination - in fact, she spends most of the book under the spell of the hypnotist Svengali (du Maurier's characterization of whom is a benchmark low in literary anti-Semitism). Yet somehow, as the critic Thomas Beer noted, "Tribly had something to do with women's independence; suffrage got tangled up with the question of nude art."[3] As the suffragists fought for virtue and the vote, Trilby's free-spirited if ultimately perilous lifestyle came to represent a sexier kind of freedom.

The phenomenon of the 'woman adrift,' which caused the single female population of America's cities to grow drastically as hopeful girls without great prospects flocked there to find work and adventure, melded with the bohemian craze to create the 'bachelor girl,' who lived in her own apartment or with a roommate, found piece work as a model or a commercial artists or catalog writer while striving to perfect her own art at home, and toasted stale bread over a hot plate for dinner when she couldn't get a student to take her out. The bachelor girl and her more privileged compatriot, the witty society hostess, made feminism fun. Those suffragists cursed with the decidedly unattractive nickname of 'bluestocking' seemed like hags in comparison. "The bluestocking, homely, severe, devoid of sentiment and tenderness, waged her grim fight against a time-hardened idea, in order that the women who came after her might enjoy an intellectual freedom such as was impossible for those that preceded her," wrote the journalist Emilie Ruck de Schell, in words very much like the criticisms post-feminists would employ one hundred years later. "The society woman of today...has gone through college shoulder to shoulder with the men who seek her companionship. Her ready wit and ingenious philosophy can interest the profoundest among them."[4]

From the turn of the century onward, bohemian women and feminists would travel for-

ward on two intertwined but ultimately disparate paths. The values of the women's liberation movement were communal and grounded in a concept of virtue that began as Christian and, over many years, mutated into goddess worship and anti-pornography politics. The mores of bohemianism elevated individuality above all, and evolved into the free enterprise and free love of the beatniks and the hippies who created the modern American counterculture. Feminism's great second wave, which began in the early 1970s, was powered by counterculture women exhausted by trying to find themselves within an individualism defined and dominated by men. But even in that revolution's glory days, the bohemian woman survived in figures like Germaine Greer and Janis Joplin. Sometimes she chastised for her unwillingness to commit to the sisterhood; at other moments, feminists tried to recuperate her, finding inspiration in her independence despite ideological difference. Consistently, she posed contradictions feminists preferred to ignore. And now, she has returned, in a moment of political confusion, to reclaim her place as the original free American female. What remains unclear, even now, is how free she has ever been.

Ada Clare was undoubtedly not the first American woman to cut her hair short and take a few chances. But the particulars of her story form a blueprint for the modern bohemian woman's life. She took advantage of the mobility created by industrialization and the rise of the city to keep transforming herself as circumstances demanded: after her debut at Pfaff's, she travelled to San Francisco, where she lived for a while, then Hawaii, where she basked in the attention of the Minister of Foreign Relations of the Hawaiian court, then back to California; when her career there foundered, she returned to New York, eventually joining a touring theatrical company. As an actress as well as a writer, she cultivated celebrity and flourished in the emerging free space between high and low culture. She was sexually free, and condemned by mainstream society for her supposedly wanton ways, while those with progressive sexual mores held her up as an example. She negotiated the slippery slope of the American class system, beginning life with some means, losing them in the war, and adapting by finding work instead of turning to a man. When she finally did marry, she chose a peer, a fellow actor, J.F. Noyes. She kept working until her death.

And her death made her into a tragedy, which Ada certainly wasn't in life. In 1874, while looking for new career prospects in New York, she paid a social visit to Sanford

and Weaver's dramatic agency. The Sanfords' pet dog jumped up and bit her on the nose as she sat and chatted. No one knew it, but the little beast had rabies. A few months later, Ada went mad during a touring production of the play *East Lynne*. She died shortly after, completely delirious. She was 38 years old. Walt Whitman, a fellow lager drinker at Pfaff's, declared, "Poor, poor Ada Clare – I have been inexpressibly shocked by the horrible and sudden close of her gay, easy, sunny, free, loose, but not ungood life."[5]

Her catastrophic mishap gave Ada's story the extra dose of pathos it needed to enter into the mythology of Bohemia. Many of the women who would follow her also faced horrible ends; in most cases, the circumstances of their lives drove them there in ways much more systematic than an accidental dogbite. Like Ada, however, these later bohemian women always started out believing they were strong, or special, enough to transcend fate. This is the characteristic she possessed that remains key to this kind of female independence: it relies on a sense of singularity, of being not like other girls. The sociologist Cesar Grana called bohemians 'the self-exiled'; for women, to inhabit this role meant rejecting the world of the feminine. The bohemian woman feels unique because she does not live in a woman's world. She is the exception in a separate sphere erected by men.

In her touching memoir of a youth spent among the leading lights of the Beat Generation, *Minor Characters*, the novelist Joyce Johnson quotes a 'dream letter' Allen Ginsberg claimed to have received from the very first Beat novelist, John Clellon Holmes, in which the master intoned, "The social organization which is most true of itself to the artist is the boy gang."[6] Holmes, who affected a tough-guy attitude, liked gangs, and Ginsberg certainly liked boys. But the poet wasn't just favoring personal quirks here. From Pfaff's to the offices of the 1920s socialist journal *The Masses*, to the Cedar Tavern where Jack Kerouac and Jackson Pollock vomited near each other, to the rock and roll parties where groupies serviced stoned musicians in the 1960s, to the 1980s East Village art scene starring Julian Schnabel and Jean-Michel Basquiat in the 1980s, and all the way to the rave parties presided over by today's computer jocks, women in bohemia have occuppied whatever extra space the men who ruled didn't devour. As consorts, they were expected to not taint these testosterone-heavy environments with too much of the feminine. Instead, they usually became tomboys, or a strange cross between tom-

boy and girl toy, allowing their femaleness to emerge in moments of sexual display or communion but otherwise acting as tomboys, flat-chested and slender and ready to rough-house.

Their femininity concealed, these women would often perform quite conventional female roles within the group. Johnson recalls a passage from the autobiography of Carolyn Casady, who famously engaged in a 'three-way marriage' with Jack Kerouac and Neal Casady in the early 1950s: "While I performed my household duties the men would read each other excerpts from their writing in progress or bring out Spengler, Proust or Shakespeare to read aloud, accompanied by energetic discussions and appraisals...I was happy just listening to them and filling their coffee cups. Yet I never felt left out. They'd address remarks to me and include me in the group with smiles, pats, and requests for opinions or to moderate an argument."[7] Unlike previous generations of housewives, Carolyn received intellectual and sexual stimulation in exchange for her cleaning and cooking. But she still was expected to make pie. Johnson did the same for Kerouac during their on-and-off affair a few years later. Elise Cowen, her best friend, kept house for the man she loved - Allen Ginsberg - Allen's lover, Peter Orlovsky (who helped with the cleaning), Peter's brother Lafcadio, and her lover, Sheila, whom she acquired, in part, to be more like Ginsberg. Not very many years after this arrangement fell apart, she jumped from her parents' apartment window in Washington Heights, killing herself.

Forty years earlier, the actress Florence Deshon had committed suicide when her own attempt at enlightened romance with Max Eastman, editor of *The Masses*, ended in failure because of Eastman's refusal to commit. In his autobiography, *Love and Revolution*, Eastman recalled a crisis he and Deshon endured one afternoon:

"[Florence] felt no glimmer of the wish to 'make a home' for a man, and I liked that. But I was unprepared for the extremes in the opposite direction to which she might go. One day, when I was absorbed in writing, she went into the kitchen to get a lunch for both of us. Coming to a blockage in my thoughts, I got oup from my desk and strolled out of the house and up the road a little way, wrestling with an idea. When I came back in about 15 minutes, she had put out the oil stove, leaving the food half-cooked, and was in the doorway in a black rage. "What do you think I am, a servant?" she said. "Do you think I came up here to cook for you while you stroll around the

countryside?" 8

Eastman tried to assure Deshon that his oblivious departure meant nothing in terms of their relationship. But later, when he finally settled down, it was with a woman who enjoyed keeping house and gardening as much as pursuing her intellectual interests, which Eastman characterized as 'play'.

Examining the relationships between several male Greenwich Village bohemians and their female companions during the 1920s, including Eastman and Deshon, the feminist historian Ellen Kay Trumberger concluded that these couples were indeed living by the rules of feminism as they saw it - but it was a feminism defined by men. Instead of freeing women from 'personal life' so that they could develop public identities, as nineteenth-century feminists had attempted, bohemian feminists strove for equality in the most intimate domestic sphere. The stated goal was to balance things out, to make men more active in the home and women more present outside of it. But such changes would follow, it was assumed, after the more important goal - of mutual sexual fulfillment resulting from a deep emotional rapport - had been achieved. What Trumberger discovered, however, was that the men who embraced this ideal actually viewed that emotional connection as a one-way current. They wanted to be able to be open and vulnerable to their women, but when the women were frank with them, as Deshon was with Eastman, they recoiled.

Reading first-person accounts by various famous bohemiennes reveals that the same scenarios occurred over and over - between Joice Johnson and Jack Kerouac, Mick Jagger and Marianne Faithfull, Kurt Cobain and Courtney Love. The men really were trying to be different, and so were the women. But they could not change the roles they'd been taught with mere will power. Structurally, in most of these cases, the situation remained the same: the man's work and ego remained at the center, while the woman struggled to determine how to nurture her own without interfering with his. And unless the money was there to hire nannies and maids, somebody had to take care of the kids and scrub the toilet. To play that role too aggressively, though, to make herself known as a mother figure, usually backfired just as severely as did Deshon's aggressive refusal. The woman who played housewife was often abandoned for a more attractively 'independent', often younger, woman - until the man in question did a complete about face, as Eastman did

when he met his ultimate match, and as Kerouac did when he retreated for good to the confines of his real mother's care.

The bohemian woman has always been expected to negotiate this gap between mother and muse on her own. "Upon her fell the whole brunt of an uncertain position in a shifting culture, for she embodied in herself much of the break with tradition. Upon her vitality and the capacity to effect an individual solution rested much of the success or failure of her adaptation," wrote the sociologist Caroline F. Ware of the Greenwich Village women Trumberger later chronicled.[9] Some women did find solutions, and these are the ones feminists and post-feminists continue to extoll. One way to reconcile the roles of wife and pal was to transform the support role into a public one, which women did often and well. The wealthy widow Mabel Dodge, who hosted spectacular 'evenings' that defined New York bohemia at the turn of the century; Sylvia Beach with her famous Parisian bookstore, Shakespeare and Company, in the 1920s; Margaret Anderson, who founded the Chicago-based *Little Review* in 1917 , publishing Ezra Pound and Djuna Barnes; Hettie Jones, who cofounded the little magazine *Yugen* with her then-husband, Leroi Jones; Gloria Stavers, who turned her love of boys in bands into a job editing *16 Magazine* in the early 1960s; Tinuviel, who cofounded the legendary *Kill Rock Stars* indie rock label in the 1990s - these are just a few examples of women who formed the support systems that have allowed the arts to thrive.

Men were not ungenerous in their gratitude to these crucial accomplices. Often, though, the language they used threw their homages in a strange light. Lincoln Steffens suggested to Mabel Dodge that she initiate her famous 'Evenings' by saying, "Men like to sit with you and talk to themselves!"[10] As if she could have anything interesting to contribute to their monologues. Andre Chamson, a novelist who went on to direct the National Archives of France, extolled Beach's entrepreneurial genius in what he thought were flattering terms. "Sylvia carried pollen like a bee," he opined. "She cross-fertilized these writers."[11] How must it have felt for a woman of Beach's status, who had outwitted censors and competitors galore, to be compared to a buzzing insect?

Despite these gentle pushes back toward solicitous silence, bohemian women found far more hope in their lives than in those that had been laid out for them by the conventional families they usually rebelled against. Merely being there, in these places where women

were never exactly women in the usual sense, gave them hope. It was that hope that eventually fueled the second wave of women's liberation in the 1960s. "By night we bloomed and ran around,"[12] wrote Johnson of herself and Cowen in the glory days of the Beats. Even despite the hindsight that allowed her to see how she had been ignored and discarded, she never stopped being glad that she'd had the chance to become something other than a nice girl.

Once, having been rejected for a low-level job at a publishing company because she was Jewish, Johnson contemplated her future in vengeful terms. In *Minor Characters*, she remembers this reverie. "Someday the publishers that would not have me as a secretary would have me as a writer. As a writer, I would live life to the hilt as my unacceptable self, just as Jack and Allen had done. I would make it my business to write about young women quite different from the ones portrayed weekly in the pages of the *New Yorker*. I would write about furnished rooms and sex."[13] She did write her novel, a few years after Kerouac was out of her life forever. She discovered her unacceptable self in the company of men, but it took that act of translating it to the page to claim it. Years, later, feminism allowed her to see another unacceptable self: the one that had threatened that male world, which kept her an unequal player in a scene she helped sustain. Giving voice to that self made her whole.

Today, young women are once again talking about their power in singular terms. They criticize feminism for forcing them to conform in words that might have come from Ada Clare, discussing the Victorian suffragists. "You may not stand out - in idea, ideology, opinion, certainly intellect, maybe even attire," wrote Adia Mivons, mocking her feminist older sisters, in the fanzine *H2So4* in the early 1990s. "Who wants to go forth from the point, raising a 'movement' or 'discipline' full of judgmental, self-involved and closed-minded 'feminists' who dictate to others in the name of 'what's best for women'? Not I, sister, not I."

Women like Mivons acknowledge that they have gained much from the efforts of their mothers to change the social structures that kept them on the periphery, and now they simply want to claim the center. Like the bohemian women of earlier eras, they plan to move as they please. But the question remains: will these post-feminist women, acting individually, be able to sustain and develop the larger changes that women's alliances achieved? Perhaps the new bohemian woman will triumph, and move us toward an age of

genuine social mobility for all. She would do well, though, to remember her sisters, from Ada Clare to Joyce Johnson, who found out that 'alone' is often a lonely and even dangerous place to be.

1 Albert Parry, *Garretts and Pretenders: A History of Bohemianism in America* , Dover Publications, New York, 1960, pp. 14 -37

2 *Lock Up Your Sons – the 21st Century Woman is in the Building*, by Tad Friend, Esquire, Februarry 1994, p. 47

3 Parry, p. 105

4 *Is Feminism Bohemianism A Failure*, by Emilie Ruck de Schell, in *On Bohemia*, ed. Cesar and Marigay Grana, Transaction Publishers, New Brunswick, New Jersey, 1990, p. 709

5 Parry, p. 37

6 Joyce Johnson, *Minor Characters*, Washington Square Press, New York, 1983, p. 83.

7 Johnson, p.94

8 Eastman quoted in *Feminism, Men, and Modern Love: Greenwich Village, 1900-1925*, by Ellen Kay Trimberger, in *Powers of Desire: the Politics of Sexuality*, ed. Ann Snitow, Christine Stansell, and Sharon Thompson, Monthly Review Press, New York, 1983

9 Caroline F. Ware, *Greenwich Village 1920-1930*, Houghton Mifflin, New York, 1935, p. 258

10 Grana, 519

11 Chamson quoted on the Princeton University Library Catalog Website, *Sylvia Beach Papers*, www.princeton.edu

12 Johnson, 263

13 Johnson, 105

Eri Kawade/James Roberts

Chinese Whispers
Social hierarchies and telematic friendship

As quite a few people have noted, the means of communication have multiplied extra-ordinarily over the last two decades and have never been more accessible. Mobile tele-phony has reached a point at which it is virtually free and has saturated its market, while in terms of purely electronic communication, initial fears about the disempower-ment of those unable to afford the expense of buying and maintaining personal compu-ters have been partially ameliorated by a strong desire to avoid techno-marginalisation amongst 'peripheral' groups such as the homeless and 'eco-activists' and, in the main-stream, the increasing accessibility of on-line connection facilities, manifested in the rise of the internet cafe and the appearance of on-line PCs at video rental shops and in many public galleries. The inevitable merger of the next generation of digital television with some form of internet access (virtually every home in the West has a TV), and Tony Blair's promise that "every schoolchild will have an email address", suggest that the next generation, at least, will take virtually free internet access for granted and will certainly be able to use it - even if their parents cannot. But as anyone who has listened to people on the train or bus making utterly useless mobile phone calls (to simply tell their office that they are *on* the train or bus is a popular favourite), or spent much time ploughing through layers of junk email (often sent from one-time accounts at internet cafes) or usenet spam (often sent from one-time accounts at internet cafés) will tell you, perhaps accessibility *per se* is not the key to communication.

There have been many pithy comments on the peculiar qualities of email and usenet newsgroups, but they do demonstrate in a very tangible way some of the essential flaws in communication, whatever means people may use to attempt to overcome them. In-deed, the internet simply exacerbates and amplifies many of these problems. One of the most intriguing, and hitherto unknown qualities is the odd tone of both email and

usenet postings. Email doesn't sit easily with prior methods of correspondence: unlike letter writing, it is hardly contemplative and reflective and there is no sense of touch, no handwriting or trace of the person who sent it. For some reason, perhaps to do with what most people associate with a keyboard and monitor, it lacks any sense of intimacy – there is a huge difference between scribbling a few words on the back of a postcard and typing those same words as an email message. A postcard has a tangibility and a sense of passage – it has physically moved from the hands of the writer to the hands of the recipient and it was probably produced in the place it was sent from – email is anodyne, stateless and formless, its appearance dependent on the recipient's operating system, email software and fonts. It is frighteningly easy to be misunderstood through email as tone and emphasis seem to be stripped away in the false sense of immediacy that the medium promotes – people seem to assume that the recipient will be thinking along the same lines as the writer, often because the writer is responding to, and has just read, an earlier message that may have been sent days or weeks ago and long since passed out of the recipient's memory. Perhaps because it seems so effortless to send email, in comparison to writing a letter, putting a stamp on it and posting it, the illusion of directness and transparency of communication is produced.

These problems appear in an aggravated form on usenet. While email at least has certain models – letter, fax, telegram – that are slowly being adapted to a new form or communication, the closest model for usenet is thousands of people standing in a large room shouting at each other and frequently not listening to what anyone else is saying. Usenet is a one-to-many and many-to-one model of communication that does not occur in real life – well, perhaps only in debates in the British Houses of Parliament. The fact that usenet postings are made in a manner similar to sending emails mean that they share its illusion of immediacy and the same problems of ambiguity of tone. While ambiguities in email can be ironed out and the correspondents often know each other well enough to guess meaning, on usenet a posting will be read by hundreds or thousands of people and interpreted in wildly different ways. The nesting and re-quoting of original messages and replies to them further complicates matters into a chain of Chinese whispers that often results in total incomprehension and someone being flamed as the perpetrator of some misdemeanour, to which, in fact, they merely replied. Rather than clarity of information, usenet seems to be a reconfiguration of a much older human pas-

time: gossip.

Hierarchical structuring is another social convention that becomes amplified in usenet, and it seems that the more specialist the group the clearer this becomes. Taking two arbitrary examples from opposite extremes of the spectrum, *alt.computing.graphics.renderman* and *alt.games.final-fantasy* [the former concerned with technical aspects of the high-end software used to produce the Disney film *Toy Story* and the latter with the role-playing game series *Final Fantasy*, one of the world's most popular Sony PlayStation games], similar patterns become obvious. Amongst the core of regular subscribers to the group there is always a figure, or figures, of authority, who 'know' the most at the top of the structure. In *alt.computing.graphics.renderman* this place is occupied by three programmers associated with Disney and Pixar [the manufacturers of RenderMan] who occupy their positions by grace of their technical skill. In *alt.games.final-fantasy* the qualifications are more arbitrary, and although every now and then a 'Lord X' or a 'Prince Y' will appear, declare themselves God and attempt to take over the newsgroup, the greatest status is accorded to the contributor with the most arcane knowledge of the game and its most obscure details. Where this position of authority is shared, each figure has a particular subset of knowledge – one that is distinct enough not to impinge on the status of the others. In varying ways the status of these figures is constantly deferred to, and therefore reinforced, by subscribers further down the hierarchy. Newcomers politely posting questions to which the answer is obvious for regular group readers will be referred to previous posts by those at the top of the tree. Newcomers posting obvious questions impolitely or without suitable deference will be ridiculed. And woe betide anyone who attempts to takeover top position in the newsgroup hierarchy without paying their dues, for they will be flamed into oblivion. Indeed, the desirability of this hierarchical position of authority is evident in the lengths to which some people will go to acquire it – forging email addresses and elaborate fictional identities of professionals with 'inside information' is one popular method of instantly acquiring usenet credibility and the status that accompanies it. And of course, while many can only dream of being 'important' in real life, on usenet, with a little dedication, those dreams can be made a reality amongst the group of people whose respect the hoaxer desires.

When watching the evolution of a newsgroup, analogous situations come to mind that

frequently occur in small groups within offices or particular social groupings such as regular drinkers in pubs or bars. Often in such groups certain individuals define their status through a specialised knowledge or even a hobby: Mr X knows everything there is to know about cars/fishing/multimedia PCs and if, as a newcomer to the group, you mention anything about the subject, Mr X will be in like a shot, asserting his authority which will be reinforced by his associates. Acceptance by such groups implicitly requires acknowledgement of such authority and the assertion of the newcomer's own, non-conflicting, area of expertise. In day to day life, such behaviour and hierarchical grouping serves to subdivide the world into digestible, knowable chunks on the part of individuals in an effort to create a place for themselves. As in large metropolises, Tokyo or London, for example, where, as the threat of urban anonymity increases and a sense of individual location in the environment declines, people attempt to carve up the city into digestible neighbourhoods and to find places where they can be 'regulars' and acknowledged as individuals, the internet presents an awesome expanse to lose yourself in. And in turn, people adopt the behavioural patterns and social groupings they use to define themselves in everyday life to do so on usenet. The major difference is that many of the conventions of interpersonal relationships in real life are no longer applicable – you can be as obnoxious, as rude and antagonistic as you want with the most severe consequence being the loss of your internet account rather than a punch in the face. With the proliferation of internet providers and the ability to change identity in five minutes, this is hardly a brake on aggression.

At its worst this is reflected in a concrete manifestation of some subscribers' most deep-seated prejudices in a way that they presumably would never do in reality. This appears in exaggerated forms of terratorialism ("you must be a dork, I can tell from your service provider that you're from Mississippi") and overt nationalism. The latter is clearly seen in the abuse that results when anyone attempts to make a non-English language posting to a newsgroup that is not prefixed with a country code, and therefore assumed by however many adolescent Americans to be solely the preserve of the English speaking world – that is, America, and those other countries whose names they can't remember. This is the most disturbing aspect of group communication on the internet: that individual identity and sense of both location and value, seem able to be created only with the exclusion and denigration of those who are not part of the group. While this is only a

reflection of what occurs in the real world, the extreme to which this is pushed in electronic communication, suggests that the desire for finding a place in the world is stronger than ever and the gap between people's aspirations and their reality is ever-widening.

"Of course, it's for money, but… everyone wants to believe they have a value and sex is the easiest way, so you feel excited when others turn their desire to you, as it means that you have some value as a man or woman. When you meet strangers, talking via *Tele Kura* [Telephone Club dating networks], making appointments, wondering what kind of person it will be, and then seeing the person for real just before meeting them, that's the most thrilling moment. Once you've met, things get real quickly, but the moment just before meeting holds the most possibilities…"[1]

It has been a while since the pager became an indispensable accessory amongst japanese teenagers, allowing them to be connected with their circle of friends anywhere. Soon the teenagers' pagers were supplanted by the cheap, short-range PHS network and the digital mobile phone, which also spread rapidly amongst the under 40s for private and business use. Now that you are equipped with a 24-hour mobile communication tool, there emerges a need to use it before you are forced to question the need to it at all for the first place – whether or not you have someone to talk to, or something to talk about. If you don't, you can just select any partner or communication topic by picking up someone's personal access number and info from *Ja-mar* magazine: "*Beru-tomo* [Pager mates] wanted: OK to beep me at any time 24 hours." (Mobiles Section; Communication Tribe: female, 18, *freeta* [freelancer, jobber]).

Throughout its 200 or so pages, *Ja-mar* is crammed with messages leading to potential encounters with strangers. You can find hundreds of others who want communication in every sense of the word. Often, the people targeted by each message are restricted by the type of communication tools they use. Some want friends to communicate only via pager – and never make face-to-face contact – while others specify which phone system or software is to be used for sending cute little characters together with voice or mail messages through mobile phones, either the digital network or PHS network. This form of telematic friendship may be best suited to three-minute sentimentalism – we all know excitement doesn't last for longer than that anyway. However, such a thirst for

connectivity is not limited to those who want only a telematic personal life.

Launched in 1995, *Ja-mar* acquired a huge circulation in a matter of weeks. The publishers went on to produce several different area-specific versions nation-wide, and now has its own satellite TV channel. Essentially, *Ja-mar* is a bi-weekly magazine which publishes private adverts for second-hand goods, information exchange and dating. It is classified into some 20 sections such as: Fashion, Music, Sports, Entertainment, Art, Parties, Food and Drink, Mobiles, Games, Pets, Health & Beauty, Collecting, Life, Encounters etc. Each section is divided into smaller groups named ...*zoku* [family/tribe], such as Rock music, Reggae, Hip Hop, Rap, Black & Soul, Heavy metal, Techno, Euro pop, Classical, Jazz, Ethnic, Japanese 70s, 80s, 90s etc., as in a record shop. It's not a particularly new genre of publication, and resembles *Loot* in London or *Junk Mail* in Johannesburg, and *Ja-mar* has links with both to exchange and reprint certain adverts world-wide. What is particular to *Ja-mar*, however, is its systematic classification of information and the cataloguing of people's personal data to allow the readers' needs to be catered for as swiftly as possible: a small table containing the advertiser's sex, age, occupation, residential area, height, blood type and access method is attached to every advert regardless of its contents. Many adverts come with a small picture showing the advertisers' face or item to be sold. To make the information easier to skim through, each section has various smaller categories and information keys: in the Encounter Section, *nai* key signifies that the advertiser places importance on the *nai-men* ['interior' or 'personality'] of the people who contact him/her, whereas the *gai* ['exterior'] key tells you the opposite – the person wants to meet someone who matches the appearance specified in the text. Some people opt for other keys to show their preferences, such as location, occupation, hobby and so forth.

Throughout the pages of *Ja-mar*, there is an implicit consensus that effectively is the norm: information is useless rubbish if it is not available instantly, and therefore every item – no matter what it is – has to be adjusted to a uniform standard, whether it is a girlfriend or an out-of-production computer game. So, you are encouraged to check a stranger's blood type (to guess what kind of personality he has) in order to be able to decide whether or not to buy their second-hand fax machine. To receive responses from an advert, you can choose one of five methods: Direct Access [to get answers directly

via phone, letter, email etc.], *Ja-mail* [to get letters via the editorial office], Quick Mail [an express version of *Ja-mail*], *Ja-matteru* [to get messages left on a mail bank that you rent from the publisher] and *Ja-matteru Plus* [a special version of the last one, allowing callers to hear your pre-recorded voice message].

But what sort of information do readers have to get from such a catalogue so urgently? However orderly the information is structured, the actual messages often render the categorisation meaningless: "What's a dragonet? What kind of fish? Can I find in an aquarium?" (Pet: Fish: female, 29 years old); "Do you know a painless…, no, non-frightening dentist? Please let me know. I can't go to dentist as I'm scared of having my mouth touched. Also want to hear your experiences if you've got over similar problems." (Health & Beauty: Miscellaneous: male, 22, student-ish); "Please let me know how to get rid of the fatty stuff around my waist." (Health & Beauty: Miscellaneous: male, 15, student); "Cute young brother wanted: I am looking for someone who will be my younger brother. Age range is from 12 to 18 and you have to be gay with a boyfriend and your blood type should be B. Preferably, you should be the youngest son in your family. It is best if you're under 170 cm in height. A cute boy, shy and a bit dependant, who plays the baby a lot. I will listen to your personal problems and give you my opinion, just like my real brother. Your elder sister will protect you." (Encounters: Miscellaneous: female); "Could you please exchange your *Pri Cla* [stick-on self-portrait photographs made with the souped-up photo booth called *Print Club*] with mine? I'm a housewife, not a beauty, don't have many rare versions, but is this alright? Let's exchange the same number of photos with each other." (Collector: Trendy goods: female, 32, housewife)

Too trivial, meticulous or absurd to believe, it is hard to tell if the people who placed these adverts ever expect an answer. Maybe they do, even though they appear to be a mere excuse for, well, either killing time or just a way of asserting their existence amongst the network of readers and writers. After all, one of the most frequently used words in the entire magazine is 'lonely', and many of the messages are just souped-up Lonely Hearts: "Please help! I'm on the edge: I've been having a shitty time at home and at school these days and have really had enough and am on the edge. Please someone, help me." (Life: Miscellaneous: female, 18, student).

Some messages are screaming out loud, without any protective barriers of anonymi-

ty, offering up the advertiser's real name and full address together with a picture of their face. The vulnerability of a lonely heart is often fully exposed to a nationwide audience to a point which makes the reader doubt whether the advertiser will be safe from the clutches of some religious cult rushing to their home.

The success of *Ja-mar* was indeed predictable, even without the change of air after the down-turn in the Japanese economy, and this type of magazine might well have been produced much earlier. Its cross-genre index encompasses all types of people as a potential audience. Although it boasts that it is not intended for profit-making or information accumulation for market research, but for free personal information exchange, the magazine is published by the corporate media giant Recruit, and simply extends the successful methods used in their other magazines for job-hunting, flat-searching etc. In a country with a population of 120 million, the audience for the personal communication and human relationship selection is enormous. Grass-root community networks cannot be structured in such an orderly way and their information distributed so widely without this mainstream outlet. In addition, the audience for this networking service is implicitly that of 'ordinary' people. The real *otaku* and maniac-obsessives, or those who want cult info exchange, continue to use their long-standing, mini-circulation 'zines or speciality publications. Thus, perhaps it's not surprising that the Encounter section of *Ja-mar* is only allowed for the exchange of personal data between heterosexuals, and any homo- or bi-sexual relationship quests have been withdrawn due to 'confusing' experiences 'ordinary' readers had in the past.

From observing *Ja-mar*, it seems that 'ordinary' people are now desperate for 'normalised and standardised' relationships – somewhere they can feel reasonably safe because of the supposedly uniform atmosphere, however diverse the magazine might appear from its index. Ultimately, *Ja-mar* stimulates one's bored nerves in a half-thrilling, half-comforting heaven in which you can satisfy the double-sided desire for encountering the unknown other and for joining a community comprised of people who reflect your 'ordinary' loneliness.

1 *Love & Pop*, Ryu Murakami, 1996

Autorenangaben / Notes on contributors:

Eva Grubinger
1970 in Salzburg geboren, studierte von 1989-95 an der Hochschule der Künste Berlin; ihre Arbeiten wurden u.a. im Städtischen Museum Abteiberg Mönchengladbach, im Neuen Berliner Kunstverein, im Museum moderner Kunst Stiftung Ludwig Wien, den Kunstsammlungen zu Weimar und der Staatsgalerie Stuttgart gezeigt. Sie lebt als freie Künstlerin in Berlin und Salzburg.
Ausgwählte Bibliografie: *Pakt* # 4, Bielefeld, April/Mai/Juni1996, s. 20, 21; *Eva Grubinger!* von Matthias Lange; *frieze* # 30, London, Sept./Okt.1996, s. 76, Martin Pesch über *Hype!, Hit!, Hack!, Hegemony!*; *Flash Art*, #197, Vol.XXX, Milan, Nov./Dez.1997, s. 117, 118, Nicolaus Schafhausen über *Cut-Outs # 1-3*; *Wired Japan*, #12, Tokyo, Dez.1997, s. 115-117, *Eva Grubinger - Bourdieu für die Sega Generation* von Krystian Woznicki; *Kunst-Bulletin* #12, Zürich, Dez.1997, s. 16 - 23, *Gruppenbild mit Dame - Eva Grubingers intelligente Gesellschaftsspiele* von Verena Kuni

Eva Grubinger, 1970 born in Salzburg/Austria; she studied at the Berlin Academy of Arts (1989-95); her work has been shown in galleries and museums including the Städtisches Museum Abteiberg Mönchengladbach, the Neue Berliner Kunstverein, the Museum moderner Kunst Stiftung Ludwig Wien, the Kunstsammlungen zu Weimar and the Staatsgalerie Stuttgart. She lives and works in Berlin and Salzburg
Selected Bibliography: *Pakt* # 4, Bielefeld, April/May/June 1996, p. 20, 21; *Eva Grubinger!* by Matthias Lange; *frieze* # 30, London, Sept./Oct.1996, p. 76, Martin Pesch on *Hype!, Hit!, Hack!, Hegemony!*; *Flash Art*, #197, Vol.XXX, Milan, Nov./Dec.1997, p. 117, 118, Nicolaus Schafhausen on *Cut-Outs # 1-3*; *Wired Japan*, #12, Tokyo, Dec.1997, p. 115-117, *Eva Grubinger - Bourdieu for the Sega Generation* by Krystian Woznicki; *Kunst-Bulletin* #12, Zürich, Dec.1997, p. 16 - 23, *Gruppenbild mit Dame - Eva Grubingers intelligente Gesellschaftsspiele* by Verena Kuni

Eri Kawade
geboren 1970 in Nagoya/Japan, ist freie Autorin; ihre Texte erschienen in *frieze*, London (*Shutter and Love: Girls are Dancin on in Tokyo*, Sept.-Okt. 1996; *Go Kato*, Jan.-Feb. 1997; *Go to Work on an Egg*, Sommer 1997; *Where are you going, Mr. Kappa?*, März-April 1998), *Bijutsu Techo*, Tokyo (*Sexuality and Gender: Collier Schorr, Nicola Tyson, Eva Grubinger, Roni Horn, Kara Walker*, Juni 1997; *The Saatchi Collection and the Real British Contemporary Art Scene*, Februar 1998) und *Studio Voice*, Tokyo (*Felix Gonzalez-Torres: A Process without End*, November 1996; *Matthew Barney: An Interview*, April 1997; *Simon Patterson*, Mai 1997; *English Rose - Tracey Emin, Georgina Starr, Gillian Wearing and Carl Freedman*, Februar 1998). Sie lebt und arbeitet in Tokyo und London.

Eri Kawade, born in Nagoya/Japan in1970, is a freelance writer whose texts have appeared in *frieze*, London (*Shutter and Love: Girls are Dancin' on in Tokyo*, Sept-Oct 1996;

Go Kato, Jan-Feb 1997; *Go to Work on an Egg*, Summer 1997; *Where are you going, Mr Kappa?*, March-April 1998), *Bijutsu Techo*, Tokyo (*Sexuality and Gender: Collier Schorr, Nicola Tyson, Eva Grubinger, Roni Horn, Kara Walker*, June 1997; *The Saatchi Collection and the Real British Contemporary Art Scene*, February 1998) and *Studio Voice*, Tokyo (*Felix Gonzalez-Torres: A Process without End*, November 1996; *Matthew Barney: An Interview*, April 1997; *Simon Patterson*, May 1997; *English Rose - Tracey Emin, Georgina Starr, Gillian Wearing and Carl Freedman*, February 1998). She lives and works in Tokyo and London.

Ann Powers

1964 in Seattle/Washington geboren, ist Popkritikerin der *New York Times*. Sie war Redakteurin der *Village Voice* und hat für die *Voice, Spin, Rolling Stone* und diverse andere Publikationen über Musik, Populärkultur und soziale Entwicklungen geschrieben. Mit Evelyn McDonnell hat sie *Rock She Wrote: Women Write About Rock, Rap, and Soul*, Delta, New York, 1995, herausgegeben. Ihre Texte wurden u.a. in folgenden Anthologien veröffentlicht: *Joyful Noise: The New Testament Revisited*, Little, Brown; *Trouble Girls: the Rolling Stone Book of Women In Rock*, Random House; *The Faber Book of Pop*, Faber & Faber; und *Stars Fall From the Sky: A Dia Foundation Project*, in Vorbereitung, Bay Press. Sie hat vielfach zu Geschlechterfragen, Sexualität und Populärer Musik Vorträge gehalten. Ihr aktuelles Projekt ist eine Untersuchung der Wertesysteme des zeitgenössischen Bohemismus, die 1999 bei Simon & Schuster erscheinen wird. Sie lebt mit ihrem Partner Eric Weisbard in Park Slope, Brooklyn, New York.

Ann Powers, born in Seattle/Washington in 1964, is a pop critic for the *New York Times*. She has been a senior editor at the *Village Voice*, and has written extensively about music, popular culture and social trends for the *Voice, Spin, Rolling Stone*, and various other publications. With Evelyn McDonnell, she co-edited *Rock She Wrote: Women Write About Rock, Rap, and Soul*, Delta, 1995. Her work has been antholigized in books including *Joyful Noise: The New Testament Revisited*, Little, Brown; *Trouble Girls: The Rolling Stone Book of Women In Rock*, Random House; *The Faber Book of Pop*, Faber & Faber; and *Stars Fall From the Sky: A Dia Art Foundation Project* to be published by Bay Press. She has lectured extensively on issues of gender, sexuality, and popular music. Her current project is an examination of the value systems of contemporary bohemianism, to be published by Simon and Schuster in 1999. She lives with her domestic partner, Eric Weisbard, in Park Slope, Brooklyn, New York.

James Roberts

1965 in London geboren, ist Redakteur von *frieze magazine*, London. Er hat eine Reihe von Ausstellungen zeitgenössischer Kunst kuratiert, darunter Julian Opie (Kohji Ogura Gallery, Nagoya, 1991), *High Fidelity* - Adam Chodzko, Rachel Evans, Douglas Gordon, Tom Gidley, Simon Patterson, Georgina Starr (Kohji Ogura Gallery, Nagoya und Röntgen Kunst Institut, Tokyo, 1993-4), *Beyond Belief* (Lisson Gallery, London, 1994) und *The Book is on the Table* - Tom Gidley, Slobhán Hapaska, Martin Honert, Collier Schorr (Ent-

wistle Gallery, London, 1996). Seine Texte erscheinen regelmäßig in *frieze* und er verfaßte Katalogbeiträge zu *A Portrait of the Artist as a Young Consumer - A Cabinet of Signs: Postmodern Art from Japan*, Tate Gallery, Liverpool und Whitechapel Art Gallery, London, 1991; *Julian Opie*, Hayward Gallery, London, 1993-4; *General Release*, British Council, Venice Biennale, 1995 (Autor and Ko-Redakteur); *Eva Grubinger, ars viva 97/98*, Staatsgalerie Stuttgart, Städt. Museum Abteiberg Mönchengladbach, Hamburger Bahnhof/ Museum für Gegenwart Berlin, Kunsthalle zu Kiel, und *Georgina Starr*, Ikon Gallery, Birmingham, 1998. Er lehrt gelegentlich an der Slade School of Fine Art und am Goldsmiths' College, London. Er lebt in London.

James Roberts was born in London in 1965. He is coeditor of *frieze magazine*, London and has curated a number of shows, including Julian Opie (Kohji Ogura Gallery, Nagoya, 1991), *High Fidelity* - Adam Chodzko, Rachel Evans, Douglas Gordon, Tom Gidley, Simon Patterson, Georgina Starr (Kohji Ogura Gallery, Nagoya and Röntgen Kunst Institut, Tokyo, 1993-4), *Beyond Belief* (Lisson Gallery, London, 1994) and *The Book is on the Table* - Tom Gidley, Slobhán Hapaska, Martin Honert, Collier Schorr (Entwistle Gallery, London, 1996). His texts are published regularly in *frieze* and he has contributed catalogue essays to *A Portrait of the Artist as a Young Consumer - A Cabinet of Signs: Postmodern Art from Japan*, Tate Gallery, Liverpool and Whitechapel Art Gallery, London, 1991; *Julian Opie*, Hayward Gallery, London, 1993-4; *General Release*, British Council, Venice Biennale, 1995 (author and co-editor); *Eva Grubinger, ars viva 97/98*, Staatsgalerie Stuttgart, Städt. Museum Abteiberg Mönchengladbach, Hamburger Bahnhof/ Museum für Gegenwart Berlin, Kunsthalle zu Kiel, and *Georgina Starr*, Ikon Gallery, Birmingham, 1998. He occasionally teaches at The Slade School of Fine Art and Goldsmiths' College, London. He lives in London.

Klaus Theweleit

1942 in Ostpreußen geboren, studierte Germanistik und Anglistik in Kiel und Freiburg. Er lebt heute mit seiner Familie als Schriftsteller in Freiburg im Breisgau, mit Lehraufträgen im In- und Ausland. Veröffentlichungen u.a.: *Männerphantasien*, Stroemfeld Verlag, Frankfurt, 1977; *Buch der Könige. Band 1*, Stroemfeld Verlag, Frankfurt, 1988; *Objektwahl*, Stroemfeld Verlag, Frankfurt, 1990; *Buch der Könige. Band 2*, Stroemfeld Verlag, Frankfurt, 1994; *Das Land, das Ausland heißt*, dtv, 1995.

Klaus Theweleit was born in 1942 in East Prussia, and studied German and English in Kiel and Freiburg. He now lives with his family in Freiburg im Breisgau, and teaches in Germany and abroad. His publications include: *Männerphantasien*, Stroemfeld Verlag, Frankfurt, 1977; *Buch der Könige. Band 1*, Stroemfeld Verlag, Frankfurt, 1988; *Objektwahl*, Stroemfeld Verlag, Frankfurt, 1990; *Buch der Könige. Band 2*, Stroemfeld Verlag, Frankfurt, 1994; *Das Land, das Ausland heißt*, dtv, 1995.